IMAGES
of America

BEALE STREET

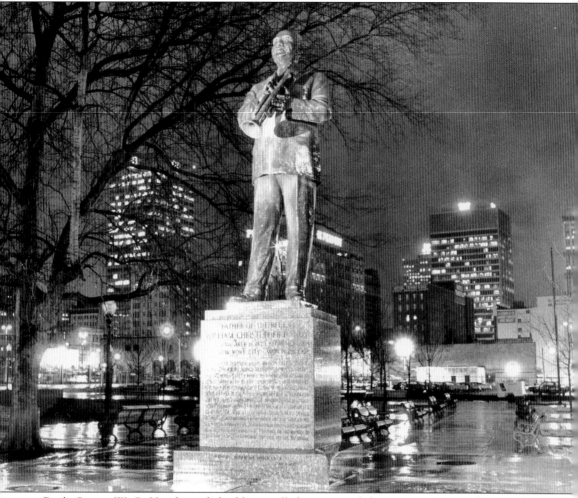

Beale Street, W. C. Handy, and the blues—all three are tightly interwoven into the complex fabric of Memphis, Tennessee. Handy's statue, in Beale Street's W. C. Handy Park, is the center of this photograph of the city's landscape at night. (Mississippi Valley Collection.)

ON THE COVER: Beale Street Elks distribute Christmas baskets. The Improved Benevolent Protective Order of Elks was organized in Memphis on June 26, 1906. Members of the lodge included black business and political leaders like Robert R. Church Jr., Harry Pace, and George W. Lee. Like most African American fraternal societies, the Elks espoused a racial uplift philosophy. The annual collection and distribution of food and toys during the holiday season was part of their community service agenda. (Memphis Room.)

IMAGES
of America

BEALE STREET

Drs. Beverly G. Bond and Janann Sherman

ARCADIA
PUBLISHING

Published by Arcadia Publishing
Charleston SC, Chicago IL, Portsmouth NH, San Francisco CA

Printed in the United States of America

Library of Congress Catalog Card Number: 2006931584

For all general information contact Arcadia Publishing at:
Telephone 843-853-2070
Fax 843-853-0044
E-mail sales@arcadiapublishing.com
For customer service and orders:
Toll-Free 1-888-313-2665

Visit us on the Internet at www.arcadiapublishing.com

BEALE STREET BLUES

I've seen the lights of gay Broadway,
Old Market Street down by the Frisco Bay,
I've strolled the Prado, I've gambled on the Bourse;
The seven wonders of the world I've seen,
And many are the places I have been,
Take my advice, folks, and see Beale Street first!

You'll see pretty browns in beautiful gowns,
You'll see tailor-mades and hand-me-downs,
You'll meet honest men, and pick-pockets skilled,
You'll find that business never ceases 'til somebody gets killed!

If Beale Street could talk, if Beale Street could talk,
Married men would have to take their beds and walk,
Except one or two who never drink booze,
And the blind man on the corner singing "Beale Street Blues!"

I'd rather be there than any place I know,
I'd rather be there than any place I know,
It's gonna take a sergeant for to make me go!

I'm goin' to the river, maybe by and by,
Yes, I'm goin' to the river, maybe by and by,
Because the river's wet, and Beale Street's done gone dry!

—W. C. Handy, 1917

CONTENTS

ACKNOWLEDGMENTS

We would like to thank the many individuals and institutions who provided invaluable assistance in helping us locate images for this book. Although Beale Street has been part of the lives of countless black and white Memphians, finding photographs that open a window on this vibrant thoroughfare is not an easy task. The work of early photographers like Earl Williams, the Hooks Brothers, and the legendary Ernest Withers is scattered in collections that are not as accessible to scholars as one might think. We owe a great debt to Dr. Jim Johnson, Patrick O'Daniel, and Gena Cordell at the Memphis Room of Benjamin L. Hooks Public Library; Margaret McNutt and Ronald Brister at the Pink Palace (Memphis Museum System); and Ed Frank in the Mississippi Valley Collection at the University of Memphis's Ned McWherter Library. We are also indebted to the many talented but often little-known photographers whose images of Beale Street are included in these collections, particularly the staff photographers for the *Commercial Appeal* (Sam Melhorn, James Shearin, Vernon Matthews, Bob Williams, Barney Sellers, and Lloyd Dinkins) and the *Press Scimitar* (Glenn Patterson, James Reid, William Leaptrott, Ken Ross, Tom Barber, Paul Dagys, Jack Cantrell, John George, Ken Ross, and William Ellis). Our University of Memphis colleagues, Dr. Douglas Cupples and Tommy Towery, also contributed previously unpublished images of 1960s Beale Street. Mr. Juan Self of Self-Tucker Architects provided information on the first Universal Life Insurance Company building, and Dr. Benjamin L. Hooks allowed us to use several Hooks Brothers photographs from the Memphis Room collection. The Riverfront Redevelopment Corporation provided the last two images in this book of the vision for Beale Street in the 21st century. We reserve a special thank you for William Bearden and Jeraldine Sanderlin. Willy not only contributed pictures—he came to our rescue, helped us figure out how to organize this project, and shared photographs and knowledge of Beale Street's blues music tradition. Sanderlin provided recollections of Beale Street in the 1940s and 1950s.

Lastly we would like to acknowledge the patience and support of our families and friends, especially Geraldus "Fuzz" Bond and the late Charles "Charlie" Sherman—still the "wind beneath our wings."

INTRODUCTION

Storied Beale Street, a street on the south side of Memphis that stretches eastward from the Mississippi River bluffs, has undergone a series of metamorphoses since the city was founded in 1819. During the antebellum period, the river end housed merchants who traded with the ships traveling the Mississippi. Several blocks east of the river, aristocratic Memphians, owners of businesses, banks, and cotton brokerages, built huge mansions on the boulevard. During the Civil War, one of these mansions (the Hunt-Phelan Mansion, the only one that still stands today) served as headquarters for Union general Ulysses S. Grant. It was there that he planned the Battle for Vicksburg.

Memphis suffered little of the destruction the Civil War wreaked on Atlanta and Vicksburg, but military occupation and demographic changes dramatically altered the social, political, and economic climate of the city. During and immediately after the war, blacks migrated into the city in large numbers. Before the war, African Americans (most of them enslaved) constituted 17 percent of the city's population; by 1865, African Americans comprised 39 percent, all of them now free.

Recovery from the war and the changes it wrought was hampered by a series of yellow fever epidemics. In 1867, the fever claimed 595 victims; in 1873, a combination of cholera, smallpox, and yellow fever claimed 2,000. Within days of the outbreak in 1878, some 25,000 Memphians fled the city. Over 5,000 died. African Americans had a significantly lower mortality rate than whites, 7 percent versus 40 percent. The remaining black citizens took care of the city. The Zouave Guard, which originated on Beale Street in 1876, protected businesses, cared for the sick, and buried the dead.

By 1890, African Americans made up 44 percent of Memphis's population, and Memphis was a city divided into clearly identifiable black and white neighborhoods with segregated hospitals, schools, churches, hotels, restaurants, and cemeteries. The heart of black Memphis was Beale Street on the southern boundary of downtown, physically close to the central commercial district but culturally and socially detached. Beale Street's leading figure was Robert R. Church Sr., who became the region's first black millionaire. A shrewd businessman who invested in real estate along the thoroughfare, he was largely responsible for the transformation of Beale Street into a vibrant center of the black community. In 1906, he established the Solvent Savings Bank and Trust Company, providing a sound financial base for black business development.

For the first three or four decades of the 20th century, Beale Street was widely known as "the Main Street of Negro America," the center for business, politics, and social and religious life, a vibrant collection of pool halls, saloons, banks, barbershops, dry goods and clothing stores, theaters, drugstores, gambling dens, jewelers, fraternal clubs, churches, entertainment agencies, beauty salons, hotels, pawn shops, blues halls, and juke joints. Above the street-level storefronts were offices for African American business and professional men: dentists, doctors, lawyers, tailors, photographers, undertakers, teachers, and real-estate and insurance brokers. Many whites, particularly recent immigrants, also lived and owned businesses in the neighborhood. As lively at night as it was during the day, Beale Street thrummed with music and revelry. Six theaters—the Savoy, Pastime, Daisy, New Daisy, Grant, and Palace—featured black vaudeville and musical entertainers. While

there was gambling in the back rooms of many establishments, high rollers flocked to the Hole in the Wall, the Midway, and the Panama. The street teemed with all manner of "carefree humans," wrote George W. Lee in *Beale Street: Where the Blues Began* (1934), including sporting men, easy riders, street-corner preachers, voodoo doctors, conjure women, snow pushers, river men, cooks and housemaids, showgirls, card sharks, laborers and yard men, guitar players, gamblers, country people in to see the sights, the famous, the infamous, and the unknown. Memphis legend Rufus Thomas, who billed himself as "the world's oldest teenager," always maintained that "if you were black for one night on Beale Street, you would never want to be white again."

Everywhere—in clubs, saloons, juke joints, and on the street—was music. A distinctive American genre called the blues evolved from African American spirituals, ballads, ragtime rhythms, work songs, and field hollers, and it found a home on Beale Street. Down at P. Wee's Saloon, an accomplished cornet player and bandleader named William Christopher Handy wrote down the songs, published them in New York, and made Beale Street the home of the blues. Musical entertainers like Cab Calloway, Louis Armstrong, Muddy Waters, Memphis Minnie, Alberta Hunter, and Bessie Smith came to Beale Street and took the Beale Street sound around the world.

By the 1950s, with the establishment of WDIA, the first all-black radio station in the nation, and the rise of Sam Phillips's Sun Studio, with artists like Rufus Thomas, Howlin' Wolf, Carl Perkins, Jerry Lee Lewis, Roscoe Gordon, Elvis Presley, and Johnny Cash, Memphis gave birth to a new kind of hybrid music that blended rhythm and blues, black gospel, and white rockabilly. The Memphis sound captured the nation's imagination and complicated notions of segregated music. First Sun Studio pushed against the barriers, then other recording companies joined the bandwagon, most notably Stax Recording Studio. Also known as "Soulsville, USA," Stax opened its doors to black and white alike and produced a string of rhythm and blues and soul hits in the 1960s.

In the 1960s, the growing civil rights movement had a profound impact on Beale Street and the city of Memphis. The central city was largely deserted by white Memphians heading east to the suburbs, taking retail establishments, businesses, and jobs with them. The combination of concentrated poverty and decentralized employment left the poor stranded. By 1968, when the city's sanitation workers went out on strike and Dr. Martin Luther King Jr. came to Memphis to lend his support, Beale Street was already significantly deteriorating from its former vibrancy. Marchers on Beale Street passed boarded-up buildings, and the violent responses to the strike added to the destruction. Dr. King's assassination on the balcony of the Lorraine Motel, just a couple of blocks off Beale Street, was the last straw. Historic downtown was largely abandoned, and Beale Street was dead. *Time* magazine dismissed Memphis as "a Southern backwater."

Before the turmoil, the Memphis Housing Authority proposed to convert Beale Street into a city centerpiece with high-rise apartments and a commercial mall. Plans were abandoned in the wake of the assassination. Within a few weeks, with racial tensions at their peak, the city's urban renewal projects leveled every building north and south of Beale Street and along one block of Beale Street itself, leaving behind a score of empty lots and a thin commercial district between Second and Fourth Avenue. Only two establishments, A. Schwab's and Hudkins Hardware, were still open for business. Only A. Schwab's, in continuous operation since 1876, has survived.

In the late 1970s, the city bought almost all properties along three blocks of Beale, and Memphis contracted with Performa Entertainment in 1982 to develop an entertainment district with three goals: to return commerce to the street, to make Beale Street a showcase for its musical heritage, and to create an environment in which both blacks and whites felt comfortable. Thus began the third metamorphosis of Beale Street.

Two important laws helped in transforming Beale. One law allowed patrons to carry alcoholic beverages in the street, and the other permitted selling liquor until 5:00 a.m. and on Sunday. Gradually tourist-oriented restaurants, bars, and entertainment venues opened along the three-block strip. Now over four million visitors stroll the street every year looking to recapture the mystique of Beale Street, but what they see is just a facade, a shadow of its former glory.

One

HISTORIC BEALE STREET

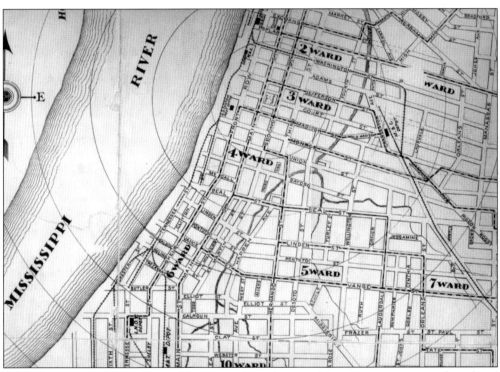

Beale Street was originally part of the town of South Memphis, a 414-acre tract purchased and developed in the 1830s and 1840s by developer Robertson Topp. Topp incorporated the town of South Memphis in 1845, and his South Memphis Company sold lots on Beale, Linden, and Vance Streets to wealthy whites and a few free blacks. In 1850, the town of South Memphis was incorporated into its more prosperous northern neighbor, Memphis. The Beale area continued to be a popular residential suburb until the late 1800s. This map shows the location of Beale Street stretching from the Mississippi River east to Pigeon Roost Road. Beale Street is the exception to the rule that thoroughfares running east and west are avenues and those running north and south are streets. Beale runs west from the Mississippi River, but it's Beale Street. (Memphis Room.)

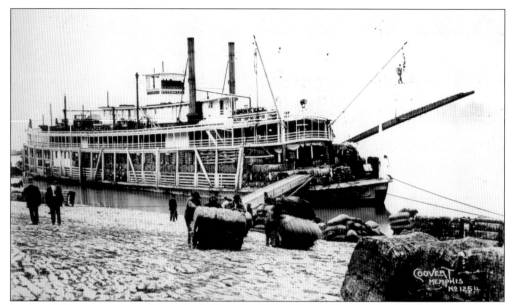

In the 19th century, steamboats docked at the Beale Street wharf to load bales of cotton and unload supplies. Roustabouts (mostly African American men) walked up from the wharf after a day's work to gather with friends in the saloons and restaurants on Beale Street. The social, economic, and racial relationships captured in this photograph were part of the Beale Street landscape for two centuries. (Memphis Room.)

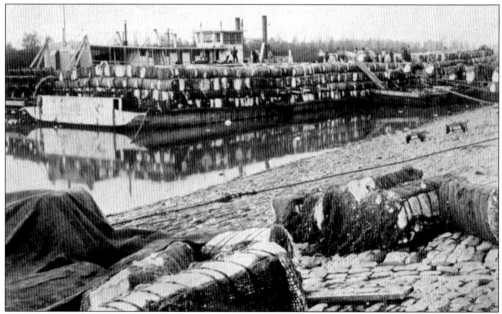

River trade played an important role in the character of Beale Street. Warehouses at the Beale Street landing were rebuilt after the Civil War battle of Memphis in 1862 and again in 1926, after a large section of the bluff was weakened by water causing the warehouses at the landing to slide down the bank into the river. Property losses were estimated in the millions of dollars. This led to the reinforcement of the river bank with concrete and landfill and construction of Riverside Drive along the riverfront. (Mississippi Valley Collection.)

ALGEO & CO.,

Wholesale and Retail Dealers in

ICE.

City, Steamboat and Shipping Trade Supplied.

Nos. 9 and 11 Beale Street.

Owned by Thomas Algeo and James Correy Jr., Algeo Ice provided supplies for the steamboats that docked regularly at the Beale Street wharf. This advertisement appeared in the 1867 city directory. (Memphis Room.)

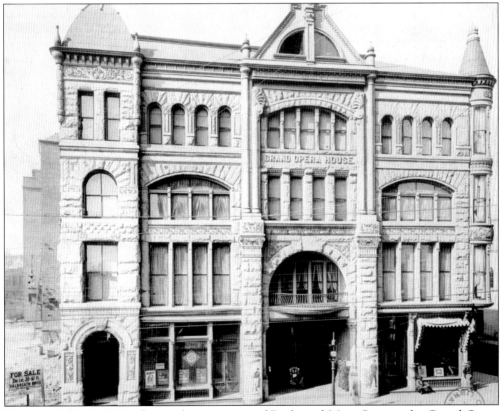

Constructed in 1889 on the southwest corner of Beale and Main Streets, the Grand Opera House was one of the finest theaters in the South and the home of the Chickasaw Guards, a regiment of the Tennessee National Guard. In the 1890s, elite white Memphians socialized in the elaborately decorated rooms of the Chickasaw Club, located on the building's upper floors. (Memphis Room.)

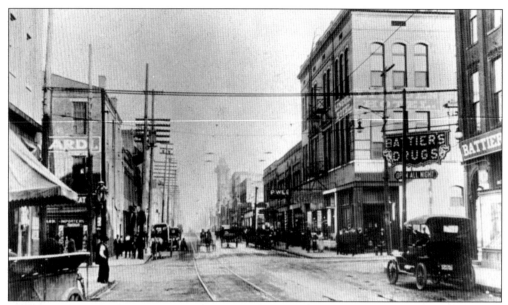

This photograph looking east down Beale Street from Hernando Street was taken about 1915. Battier's Pharmacy opened in 1896. Its all-night services were convenient for Beale Street's rowdier elements. The first floor of the building on the southeast corner housed the Orleans Café, while the Lincoln Hotel was on the second and third floors. Next door to the Orleans Café/Lincoln Hotel was P. Wee's, where W. C. Handy wrote his first blues songs. The building on the northeast corner of the Beale Street/Hernando Street intersection was occupied by several grocers between 1869 and 1918. (Mississippi Valley Collection.)

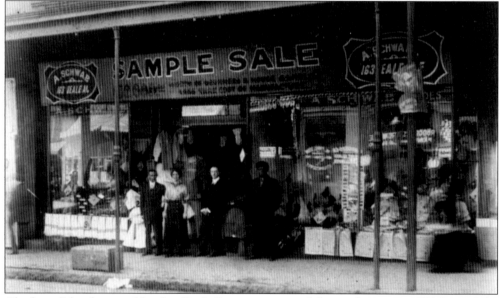

Abraham Schwab opened his first Beale Street grocery and dry goods store in 1876. In 1912, he moved the business from 149 to 163 Beale Street. Twenty-four years later, Schwab expanded into the neighboring building at 165 Beale Street, which was occupied by a Piggly Wiggly grocery store. Schwab's history mirrors that of other immigrant merchants on Beale Street. The store has served the Beale Street community for 130 years. (Memphis Room.)

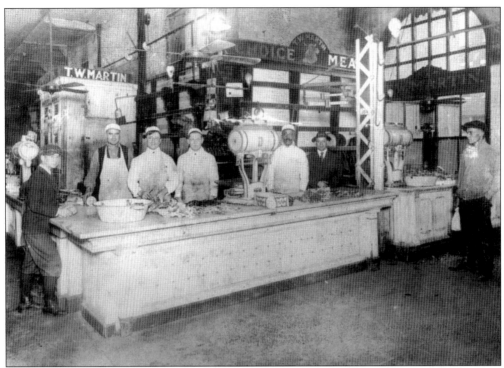

The first Beale Street market (the South Market) was constructed at Beale and Third Streets in the mid-1800s. Its New Orleans–style market area consisted of a large, slate-roofed shed with a long brick walkway in the center. Meat stalls occupied the center walkway with fruit and vegetable stalls on either side. In 1896, the city constructed a large three-story, glass-domed brick market at Beale and Third Streets. This 1919 photograph shows the stall of butcher T. W. Martin. (Memphis Room.)

Food dealers in the Beale Street Market sold a variety of products including vegetables and assorted meats. The market opened at 2:00 a.m., and the closing bell rang between 9:30 and 10:00 a.m. Market hours shifted to 4:00–9:00 a.m. during the Civil War. Until the late 1800s, most of the marketing was done by the men in the household, often accompanied by servants who carried the merchandise. (Memphis Room.)

These 1867 advertisements illustrate the variety of businesses operating on Beale Street in the 19th century. (Memphis Room.)

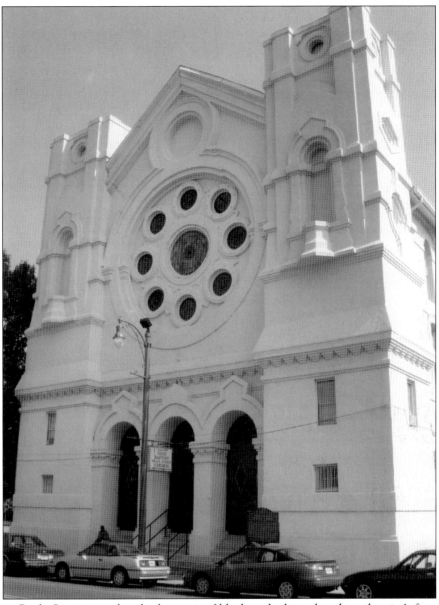

Historic Beale Street was also the location of black and white churches, the city's first black park and auditorium, banks, and the offices of black professionals. Historical First Baptist Beale is located at the corner of Beale and Fourth Streets. It is one of the oldest African American congregations in Memphis. In the 1860s, the African American members of the predominantly white First Baptist Church on Beale Street began raising funds to construct their own church building. The basement was completed in 1868, but construction of the church edifice was not completed until 1885. Historical First Baptist Beale was the first brick multi-storied church in the United States to be constructed by African Americans for African Americans. Originally one of the twin towers was topped by a cupola-like structure with square piers supporting arches crowned by a Celtic cross. At the top of the other tower was a tin statue of St. John the Baptist with his arm pointing heavenward. The cupola fell into the church's nave in 1885 and the statue was removed after it was also damaged by lightning. (Beverly Bond.)

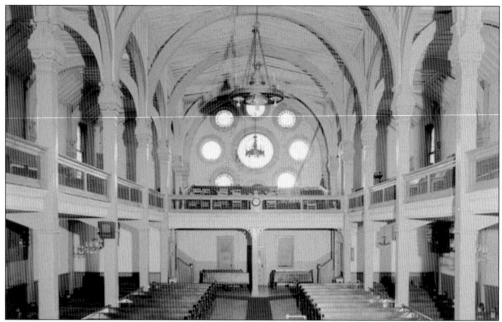

Pastors of Historical First Baptist Beale included Rev. Morris Henderson, R. N. Countee, and N. T. Nightingale. From 1889 to 1891, Nightingale, J. L. Fleming, and Ida B. Wells published the *Free Speech and Headlight* from the basement of the church and later from 169 Beale Street. Another member of the congregation, attorney Thomas F. Cassells, handled Wells's lawsuit challenging Tennessee's railroad discrimination. (Library of Congress.)

The 2,200-seat Church's Park Auditorium was built in 1899 by Robert R. Church Sr., one of the wealthiest African Americans in the South, as the centerpiece of Church's Park. Church's office was at one end of the auditorium. The grounds surrounding the auditorium were elaborately landscaped and provided picnic areas, playgrounds, and recreational areas for black Memphians at a time when there were few similar venues open to them in the city. (Memphis Room.)

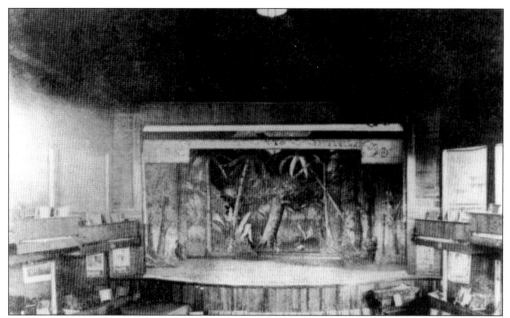

The theater in Church's auditorium had a seating capacity of 2,200, with large galleries around the interior and an elevated stage. The facilities were used for civic and church meetings, conventions, vaudeville shows, political and fraternal organizations, and musical performances like those of opera singer Madame Sissieretta Jones, the Fisk Jubilee Singers, and big bands like the Jimmie Lunceford Orchestra. (Memphis Room.)

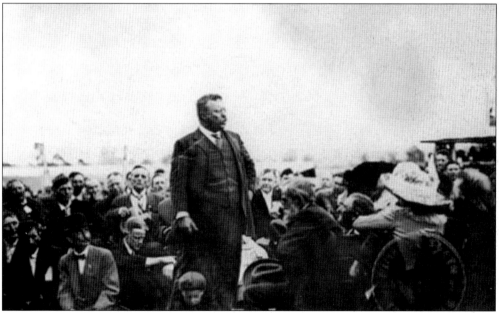

In November 1902, over 10,000 black and white Memphians gathered in Church's Park to hear Pres. Theodore Roosevelt. Roosevelt later spoke to about 3,000 black Memphians in Church's auditorium. A procession of 25 horse-drawn carriages accompanied by 25 men on horseback circled the park three times after Roosevelt's speech to give all the spectators an opportunity to see the president. (Memphis Room.)

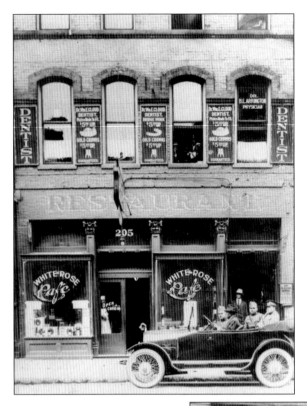

African American professionals like Drs. William McCloud and B. L. Arrington, had their offices in rooms above Beale Street businesses like the White Rose Café. Other black-owned cafés included the Talk-O-Town, North Pole Sandwich Shop, Lone Star Eat Shop, and Harlem Café.

In 1906, Robert R. Church Sr., T. H. Hayes, J. T. Settle, Dave Washington, and other black businessmen established the Solvent Savings Bank and Trust Company on Beale Street between Fourth and Turley Streets. It was the first black-owned bank in the city. Four years later, J. Jay Scott and H. Wayman Wilkerson organized the Fraternal Savings Bank. The two institutions merged in 1922. (Mississippi Valley Collection.)

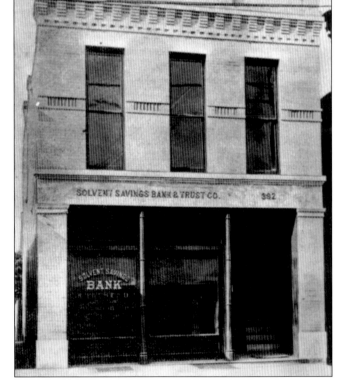

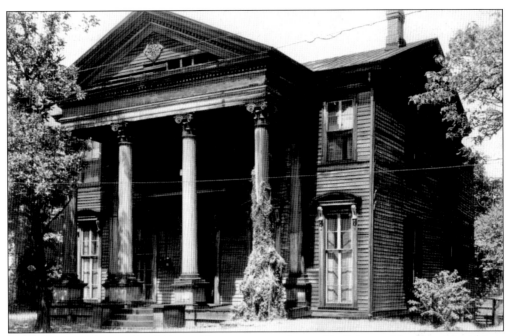

This two-story, 14-room Greek Revival house was one of several built by wealthy white Memphians when the eastern end of Beale Street was a popular residential area. The house was constructed by Robertson T. Torian in 1861. H. A. Littleton purchased the property four years later but sold it in 1876 to James T. Pettit. Pettit came to Memphis in 1847 and became a successful planter, cotton factor (or broker), and commission merchant. (Memphis Room.)

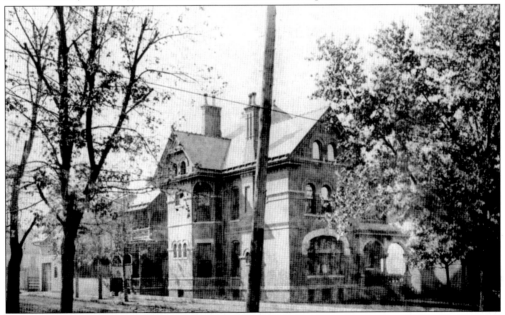

Built on part of the original estate of Eli Driver, this house was constructed in 1892 by Dr. Richard B. Maury. Maury's father had been private secretary to Pres. James Monroe. Another Maury relative was responsible for building the Memphis Navy Yard in the 1840s. In the 1880s, Dr. Maury was instrumental in developing the city's hospital system. (Memphis Room.)

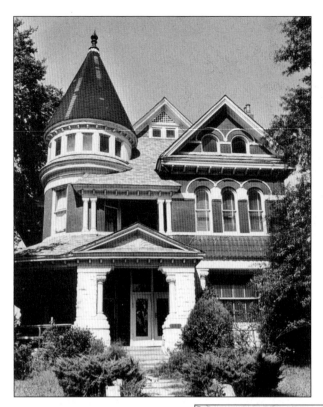

This late-19th-century Victorian-style house at 488 Beale Street was the home of Henry Wetter, president of H. Wetter Manufacturing Company. In the early 20th century, the families of African American businessmen and professionals began buying homes a few blocks from Beale Street along Vance Avenue, Lauderdale Street, and Wellington Street. (Memphis Room.)

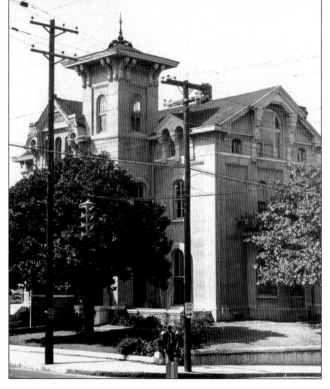

The Randolph Mansion was built in 1875 by William M. Randolph, who served as city attorney from 1869 to 1874 and later as a judge. In 1891, Randolph built a seven-story office building, the Randolph Building, at the corner of Beale and Main Streets. Despite its designation on the National Register of Historic Places, the Randolph Mansion was demolished in 1976 after years of neglect, fires, and vandalism. (Memphis Room.)

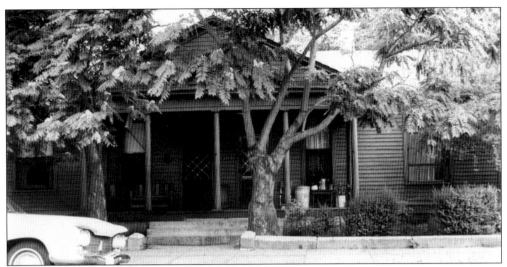

Rich and poor, black and white rented or owned property in the Beale Street area. In 1846, Milly Swan, a free black woman, bought a lot on Linden Street near Beale Street, which she owned until the 1870s. Other free blacks, including Milly's sister Charity Swan, Joseph Clouston, Mariah Batte and her sister, Agnes Alexander, Ellen Burton, Thomas Bradshaw, and Lewis Graham also owned property on Linden, St. Martin, and Turley Streets. (Mississippi Valley Collection.)

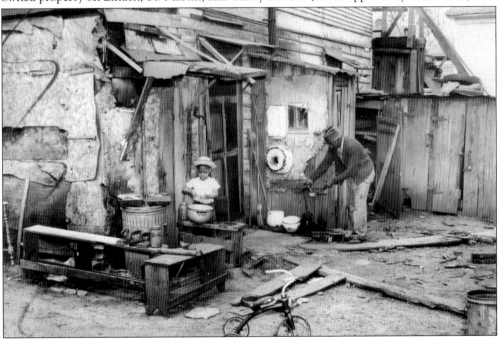

In the late 19th and early 20th centuries, blacks lived in all sections of Memphis. Some moved northeast to Douglass Park or southeast to Orange Mound, but most generally inhabited the poorest areas of the city, places like "Slippery Log Bottoms," "Queen Bee Bottoms," and "Shinertown." Some lived in small, frame cottages, boxed cabins, or "shotgun" houses, with communal outdoor toilets or pit privies. This housing reflected the economic difficulties of many black Memphians. Beale Street was where they came to shop, to visit legal or health-care providers, or just for entertainment. (Memphis Room.)

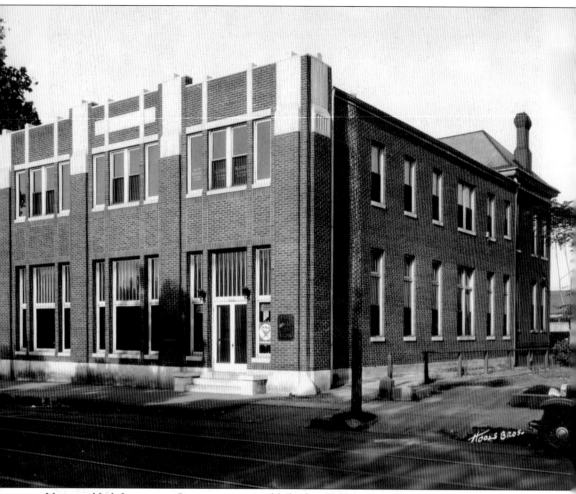

Universal Life Insurance Company was established in 1923 by Dr. J. E. Walker, former president of Mississippi Life Insurance Company. The company's first offices were in the Fraternal Bank building on Beale Street. In 1926, Universal Life moved into its own building at 234 Hernando Street near Beale Street. In 1947, Universal Life became the second African American business in the United States to achieve million-dollar status. Other African American insurance companies with offices on Beale Street included North Carolina Mutual and National Benefit Life. Atlanta Life Insurance Company also had an office on Hernando Street near Beale Street. (Memphis Room.)

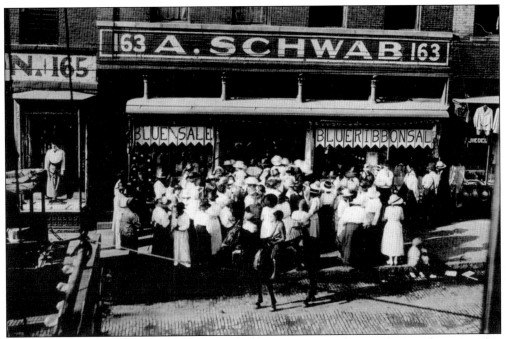

Beale Street businesses met the needs of blacks from Memphis and surrounding rural communities who were often not welcome in Main Street establishments. A. Schwab's department store, established in 1876, carried a wide variety of goods and held regular sales that drew great crowds. (Memphis Room.)

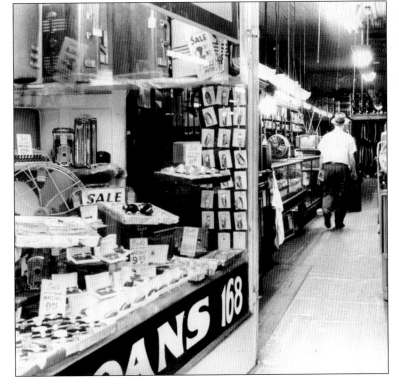

Located across the street from A. Schwab's, this loan office offered a variety of retail products. Like A. Schwab's and Greener's, the loan office catered to customers looking for bargains in the shops along Beale Street. (Mississippi Valley Collection.)

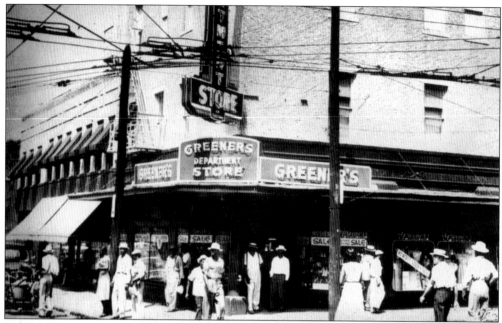

Greener's was also a full-service department store carrying household goods, clothing, hardware, and assorted dry goods. It opened in 1928 on the northeast corner of Beale and Hernando Streets, and remained in business until the early 1960s. Pat O'Brien's Restaurant and Bar, a replica of the establishment in the French Quarter in New Orleans, now stands on this spot. (Memphis Room.)

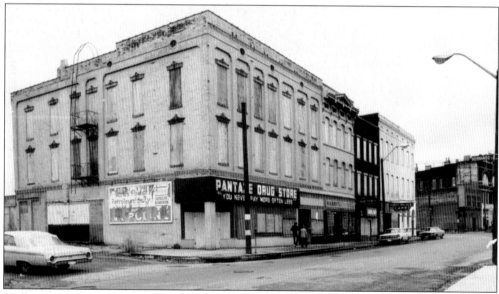

Pantaze Drug Store was at 209–211 Beale Street, on the southwest corner of Beale and Hernando Streets. From 1896 until 1929, it was called Battier's. Abe Plough, who founded Plough Pharmaceuticals, was proprietor of Battier's in the early 1920s; there he developed and sold St. Joseph's Aspirin. The store became Pantaze in 1929 and stayed in business until the 1960s. The Center for Southern Folklore later occupied the building. Then in 1999, Wet Willie's, a daiquiri bar, took over the space. (Memphis Room.)

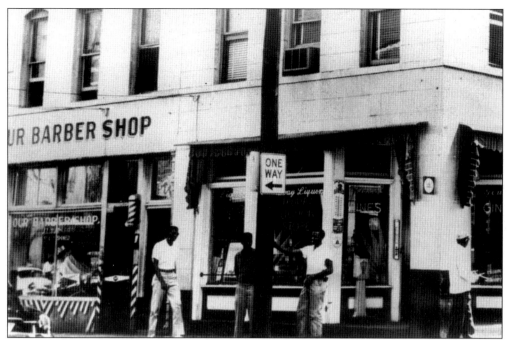

Barbershops were places for sharing gossip and meeting friends, as well as gaining professional assistance with personal grooming. They were the daytime equivalent of the saloon. Several flourished on Beale Street, one of them simply called "Our Barber Shop." (Memphis Room.)

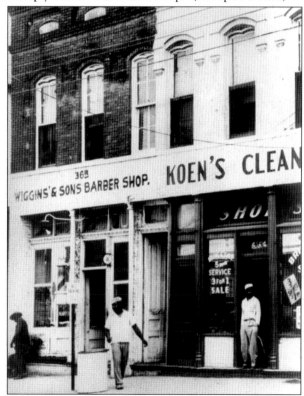

Wiggin's and Sons Barber Shop was another popular meeting place on Beale Street. (Memphis Room.)

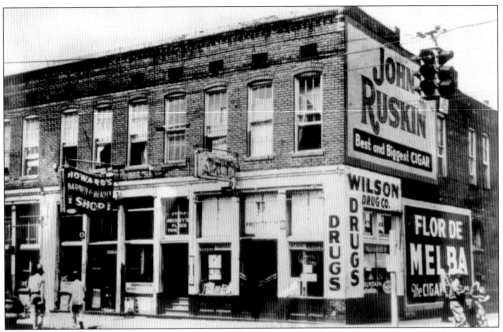

By the 1930s, there were as many as 15 barbershops on Beale Street. Pictured in this photograph, Howard's Barber and Beauty Shop was sandwiched between Wilson Drugs (350 Beale Street), where kids went for a soda after school, and the Avalon Pool Room. Barbershops offered more than the customary shave and haircut. They were places where social, political, economic, and intellectual problems were debated and sometimes resolved. (Memphis Room.)

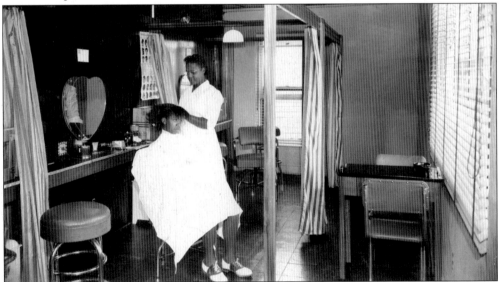

Looking rather lonely in this pristine beauty shop, these ladies were perhaps posing for an advertisement photograph. Beauty shops were important gathering spots where women did more than share the latest gossip. In the Jim Crow South, these social spaces were also arenas where African American women held political discussions or conducted civic business. Hattie Burchette Reid and Gorine Morgan Young were two of Beale Street's most successful hairdressers. (Memphis Room.)

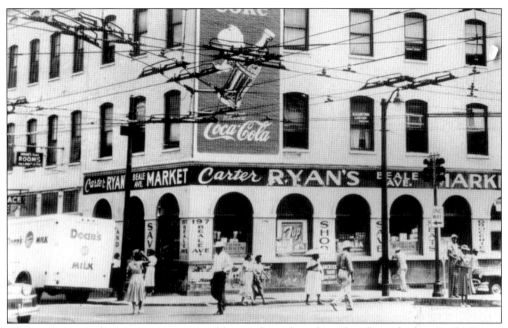

There were several grocery stores, vegetable stands, and markets that flourished on Beale Street. Carter Ryan's Beale Avenue Market occupied the ground floor of this building on the southeast corner of Beale and Hernando Streets. This was once the site of the Fraternal and Solvent Savings Bank and Trust Company, which went bankrupt in 1927. Upstairs were offices for black professionals. The site is now Alfred's Restaurant and Bar. (Memphis Room.)

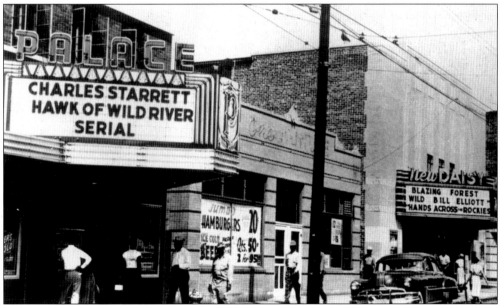

Double theaters, the Palace and the New Daisy, are both featuring westerns on this afternoon in 1940. The first theater on Beale Street that catered to African American audiences was the Pastime, which opened in 1909. The Palace was built by Fred Barasso and the Pacini Brothers and was the South's largest theater for African Americans. The Lincoln, a black-owned theater, was located on Beale Street between Hernando and Fourth Streets. (Memphis Room.)

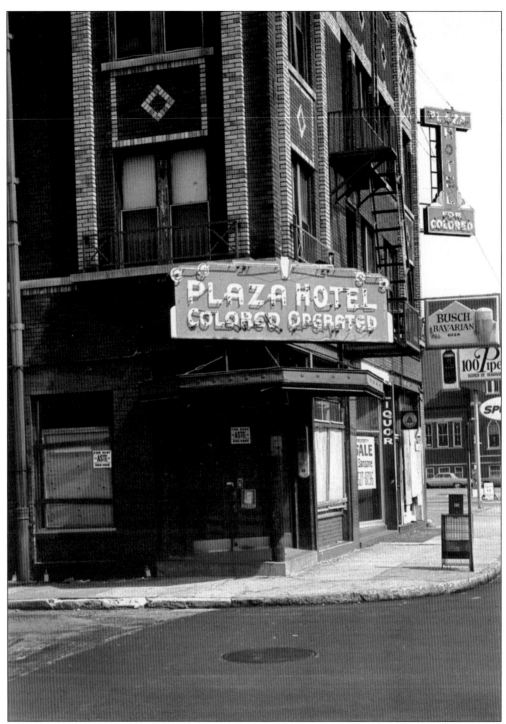

The Plaza Hotel had fallen on hard times by the time this photograph was taken in the 1960s, but it had once been a thriving "colored operated" business. Hotels like the Plaza served a clientele that had no access to more prominent establishments like the Chisca on Main Street or the Peabody on Union Avenue. (Douglas Cupples.)

Loan companies and pawnbrokers thrived on Beale Street, where people frequently hocked their possessions so that they could make it between paychecks. Safferstone's Loans was the last occupant of 167 Beale Street before the wrecking ball took down the building in the late 1960s. (Memphis Room.)

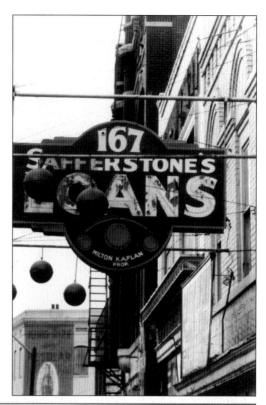

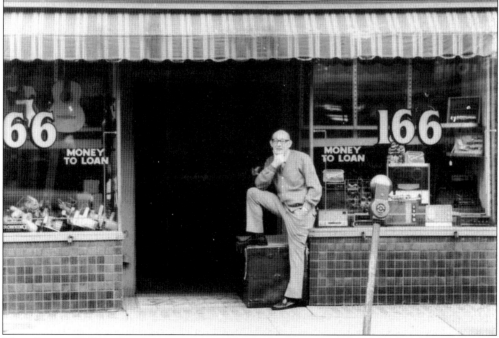

Next door to Safferstone's Loans, at 166 Beale Street, was Morris Lippman's pawnshop, which became Epstein's Loan Office in 1935. The building is now occupied by the King's Palace Café. (Mississippi Valley Collection.)

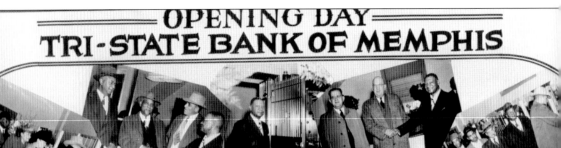

OPENING DAY
TRI-STATE BANK OF MEMPHIS

MONDAY DEC. 16. 1946.

Tri-State Bank opened its Beale Street office on December 16, 1946. Tri-State was Memphis's third black-owned bank, all of which had offices on Beale Street. Tri-State was established by Dr. J. E. Walker, founder of Universal Life Insurance Company. The main office remained on Beale Street until the 1970s, when it moved west to its present location on Main Street at Beale Street. Tri-State, with branches around Memphis, is one of the nation's most successful black-owned businesses. (Memphis Room.)

Two

"The Main Street of Negro America"

Few African Americans owned property on Beale Street, but many rented residential or occupational spaces in buildings on the street or on neighboring streets and alleys. Robert (Bob) and Anna Wright Church were exceptions to this rule. In the late 1800s, Church made his fortune in real estate, saloons, and billiard halls in the Beale Street area. He paid $1,000 to purchase Bond No. 1 to help the city regain its charter in the 1890s. Anna Wright Church, one of the first generation of African American teachers in the city, was a prominent figure in African American women's cultural, literary, and social organizations. (Mississippi Valley Collection.)

Born in Memphis before the Civil War, Martha Ferguson operated a hand laundry business that specialized in fine linen, lace, and silk. Like many other African American women, she used the income from this profitable business to support her family and to educate her daughter, Ida, who attended a school in Antioch, Ohio, with Anna Wright and also taught in the city's black schools. (Mississippi Valley Collection.)

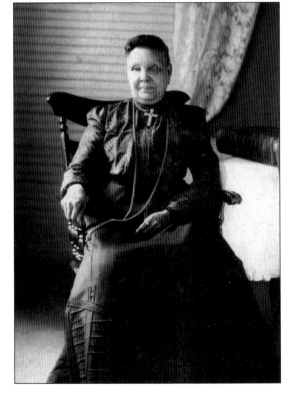

Dora Clouston was the wife of Joseph Clouston, an antebellum free black man and one of a small number of African Americans who owned property in the Beale Street neighborhood before and after the Civil War. Joseph Clouston also operated a grocery store and barbershop at 145 Beale Street in the late 1800s. (Mississippi Valley Collection.)

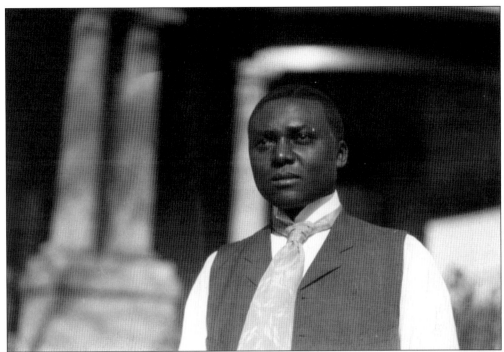

Most African Americans in Memphis were working-class people, many of whom migrated to the city from the Mississippi Delta or eastern Arkansas. In 1860, African Americans were only 17 percent of Memphis's population. Ten years later, in the aftermath of the Civil War and Reconstruction, blacks were nearly 39 percent of the city's population; by 1890, in the aftermath of yellow fever epidemics and rural migrations, blacks were 44 percent of the total population. Most black men worked as domestic servants or as laborers in the city's cotton-related industries, while most black women worked as cooks, domestic servants, midwives, nurses or laundresses. As writer George W. Lee noted, "Saturday night [Beale Street] belongs to the cooks, maids, houseboys and factory hands," who enjoy the street's theaters, poolrooms, or juke joints. But Sunday was also the time that many of the same people spent in the churches in the Beale Street neighborhood. "Lizzie Rollin" and "Andrew," shown in these two photographs from the collection of photographer Abraham Frank, were servants in the Frank household and most likely weekend visitors to Beale Street establishments. (Mississippi Valley Collection.)

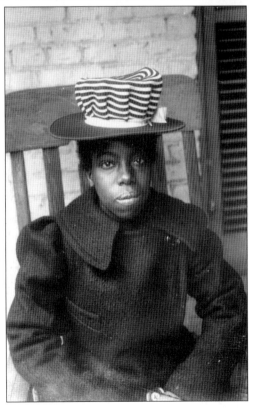

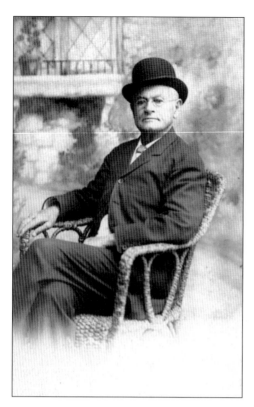

Robert Church Sr. was instrumental in the transformation of Beale Street from an elite residential community to a thriving commercial center. Church operated several saloons on Beale or adjacent streets and bought up property in the area as other Memphis landowners fled during the yellow fever epidemics of 1878 and 1879. By the early 1900s, Church was the "kingpin of Beale Street." (Mississippi Valley Collection.)

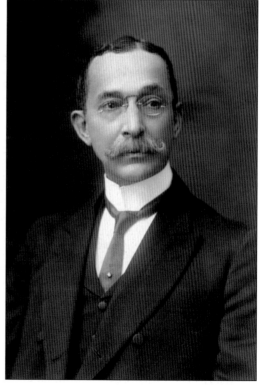

Another prominent black Memphian, Josiah T. Settle, was one of the city's finest lawyers. Along with Benjamin F. Booth, Settle argued Mary Morrison's case when she challenged segregation on the city's streetcars in 1905. Community meetings in Church's Park raised $5,000 to bring Morrison's case to the Tennessee Supreme Court, but Settle and Booth could not reverse the national trend toward racial segregation. (Mississippi Valley Collection.)

In the early 1900s, Robert R. Church Jr. returned to Memphis to manage Church's Park and Auditorium. He succeeded his father as president of Solvent Savings Bank but later resigned to concentrate on real estate and politics. Church founded and financed the Lincoln League, a local organization established to organize and register black voters, and he was a charter member of the Memphis branch of the NAACP. Both organizations met in Church's auditorium. (Mississippi Valley Collection.)

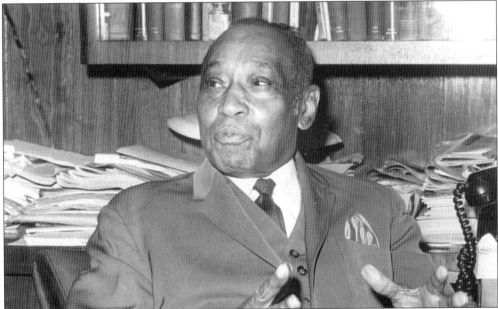

After serving in the army in World War I, Lt. George W. Lee (the "Boswell of Beale Street") returned to Memphis and became Robert Church's most important assistant. Lee managed the Memphis branch of Atlanta Life Insurance Company and became a leader in the Beale Street Elks and in local, state, and national Republican Party affairs. Lee was an important political and cultural leader on Beale Street until his death. (Mississippi Valley Collection.)

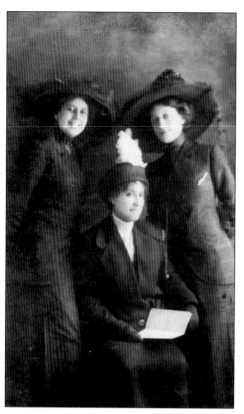

Pictured from left to right are Sara Johnson Church (Mrs. Robert Church Jr.), Mary Church Terrell (daughter of Robert Church Sr.), and Annette Elaine Church (daughter of Robert Church Sr.). The photograph was taken in 1912 at funeral services for Robert R. Church Sr. Mary Church Terrell was born in Memphis but moved to New York with her mother and brother after her parents divorced. She became a leader in movements for women's suffrage and civil rights and, in 1896, was the first president of the National Association of Colored Women. Sara Church and Annette Church, along with Anna Wright Church, were the only three women among the charter members of the Memphis branch of the NAACP. (Mississippi Valley Collection.)

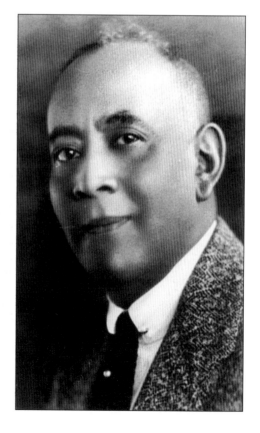

Alonzo Locke, headwaiter at the Gayoso Hotel and later at the Peabody Hotel, was a leader among the city's working class. Locke trained many of the young men who became waiters or bellhops in the city's hotels and restaurants. Through his connections with prominent whites, Locke was able to secure jobs for blacks in the hotel system. In the 1960s, men like David Franklin provided this same kind of mentoring for young black men at the Parkview and Rivermont Hotels. (Mississippi Valley Collection.)

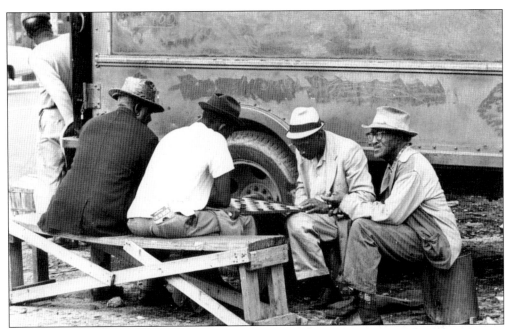

The yards and alleyways around Beale Street were places where the business of the street, the city, or the nation could be discussed over a friendly game of checkers. These games seldom aroused the level of emotion that often occurred in Beale Street saloons or gambling halls, and they were often evidence of the community beyond or behind the blocks between the river and Hernando Street. (Mississippi Valley Collection.)

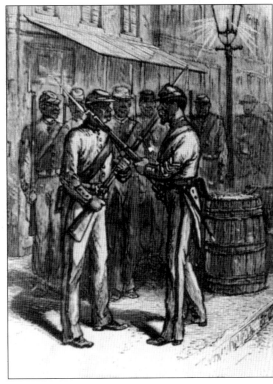

African Americans first joined the city's police department in the 1860s, but they worked as turnkeys in the stationhouses on Causey Street at Linden Avenue and on Adams Street, not as uniformed officers walking beats. During the 1878 yellow fever epidemic, the Zuoave Guard, a black militia group that originated on Beale Street in 1876, joined black policemen in patrolling the city at a time when most of the white police force died or fled the city. (Memphis Room.)

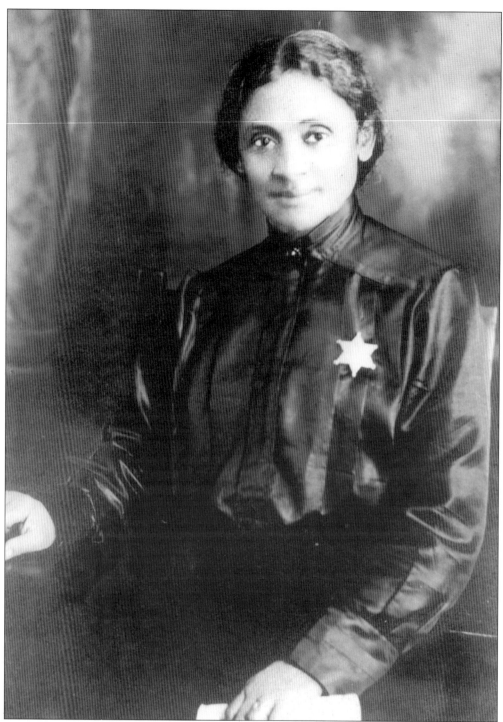

Julia Hooks, the "Angel of Beale Street," operated a music school in Church's Park Auditorium. Hooks was one of the first generation of black teachers in the Memphis Schools. She left the schools and opened a kindergarten and music school in her home on South Lauderdale Street. Hooks was also employed as an officer of the Juvenile Courts. (Mississippi Valley Collection.)

No black men were hired as Memphis police officers from 1919 to 1948. White officers patrolled Beale Street and other black neighborhoods. This picture shows an unidentified white patrolman arresting a man outside Dr. J. B. Martin's Pharmacy on Florida Street. Martin was a close associate of Robert (Bob) Church Jr. In the late 1930s, political and economic harassment eventually forced the two men to leave the city. (Mississippi Valley Collection.)

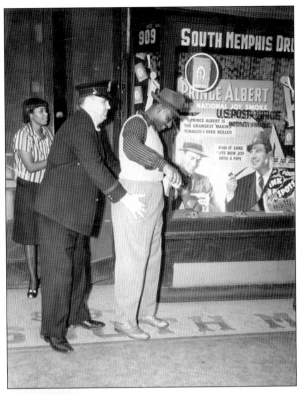

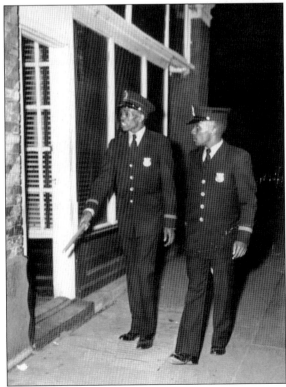

In 1948, fire and police commissioner Joseph P. Boyle appointed nine black men to the force. This picture shows two of the nine, Wendell Robinson (left) and Claudius Phillips (right), walking their beat on Beale Street. Almost 30 years later, Robinson became the first black man to command a detective squad. (Mississippi Valley Collection.)

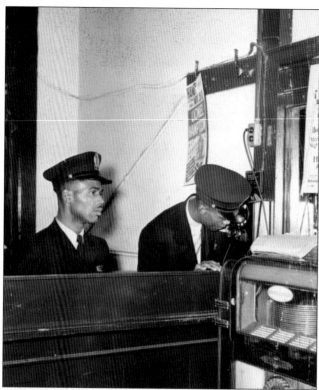

Officers Roscoe R. McWilliams, on the left, and Jewel R. Jubert, on the right, report to police headquarters from a café on Beale Street. Jubert, McWilliams, Claudius Phillips, and Wendell Robinson stood their first roll call in the auditorium at 4:00 p.m. on November 5, 1948. Their first tour of duty was patrolling the Beale Street area until midnight. It was, according to Nat D. Williams, a "historic night on Beale Street." (Mississippi Valley Collection.)

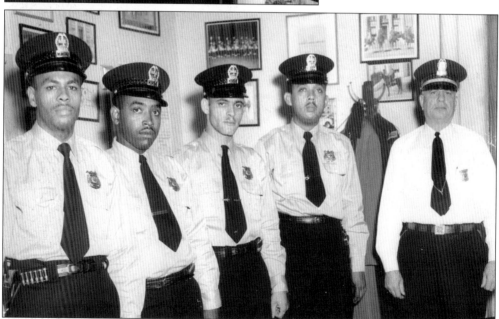

Black policemen were soon allowed to patrol areas other that Beale Street, and a second class of black police officers was appointed in 1951. The four officers pictured above are, from left to right, James Presley, Elmo S. Berkeley, Thomas Marshall, and Benjamin Whitney, with Inspector W. J. Rainey on the far right. Thirty years later, Marshall became the first African American deputy chief in the Memphis Police Department. (Mississippi Valley Collection.)

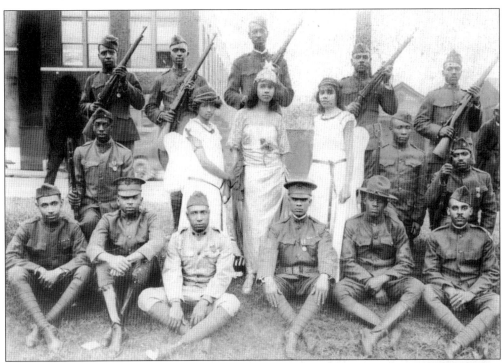

This 1923 Armistice Day celebration included a parade down Beale Street. George W. Lee, a veteran of the war, was executive committeeman of the predominantly white state American Legion. Lee, along with Dr. R. Q. Venson and other black veterans, was instrumental in organizing the Autress Russell Post No. 27 of the legion, which by the 1930s was the largest African American legion post in the world. Autress Russell was the only black Memphian killed in France during World War I. (Pink Palace.)

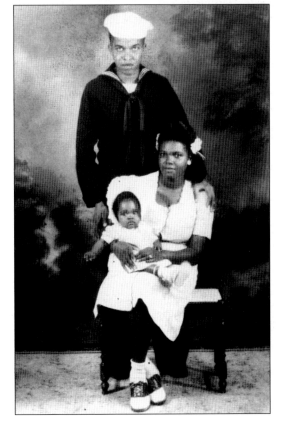

Black men enlisted or were drafted into the military during World War II. Many young sailors and soldiers came to Beale Street to have their pictures made by veteran photographers at Blue Light or Hooks Brothers studios. This photograph, made at Blue Light, shows Julius and Freddie Franklin Greene with their young daughter, Pauletta, in early 1945. (Beverly Greene Bond.)

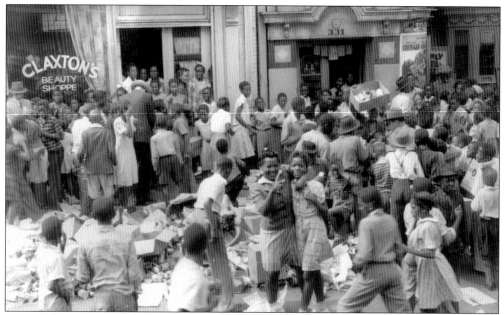

During World War II, the City Beautiful Commission sponsored scrap drives to gather salvageable materials for the war effort. Children were encouraged to bring cans and metal, scrap paper and magazines, old toothpaste tubes, inner tubes, and old tires to "Tin Can" matinees and exchange them for admission to the movies. Hundreds of black children attended this Saturday matinee at the Palace Theater. (Memphis Room.)

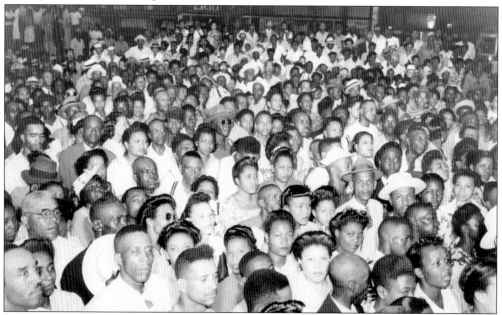

African Americans joined in the war effort by organizing drives to purchase war bonds. This Beale Street dance drew hundreds of people eager to add their support to the war effort. Many considered this part of a "double v" campaign for victory over the Axis powers and over racism at home. These successful bond drives raised a total of $1.5 million in Memphis's African American community. (Memphis Room.)

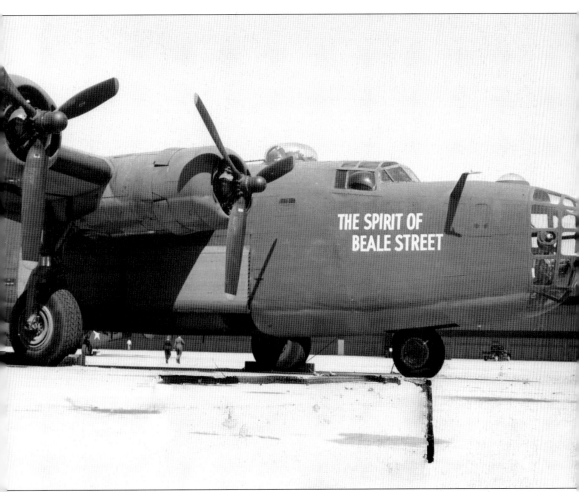

THE SPIRIT OF
BEALE STREET

Black leader George W. Lee spearheaded a successful war bond drive that raised $303,000, the amount needed to build a B-24 Consolidated Liberator bomber. The one pictured above was renamed the *Spirit of Beale Street* to celebrate the war efforts of Memphis's black community. Sixty years later, Pinnacle Airlines (Northwest Airlink) commemorated the event by naming their 100th Canadair Regional jet the *Spirit of Beale Street*. (Memphis Room.)

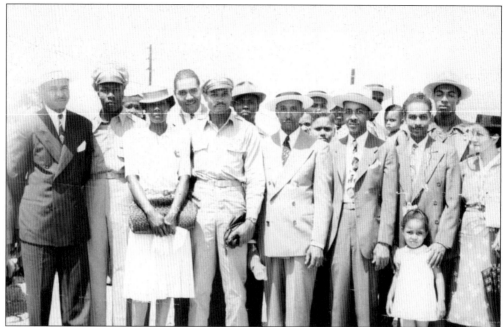

On June 25, 1925, Memphis celebrated "Capt. Luke Weathers' Day." Weathers (fifth from left) was a 1939 graduate of Booker T. Washington High School. He flew a P-51 Mustang with the 99th Pursuit Squadron, part of the 332nd Fighter Group (the Tuskegee Airmen). Their mission was to protect American bombers flying missions over Italy and Germany. (Memphis Room.)

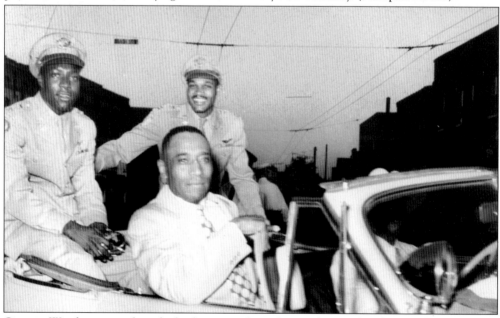

Captain Weathers, seated on the back seat on the right, was honored with a parade down Beale Street to Handy Park, where he was presented a key to the city, the first such honor for a black man in Memphis history. Weathers flew 71 missions over Europe in 14 months and shot down seven enemy fighters before he was shot down over Greece. He was awarded the Purple Heart and the Distinguished Flying Cross with seven clusters. (Memphis Room.)

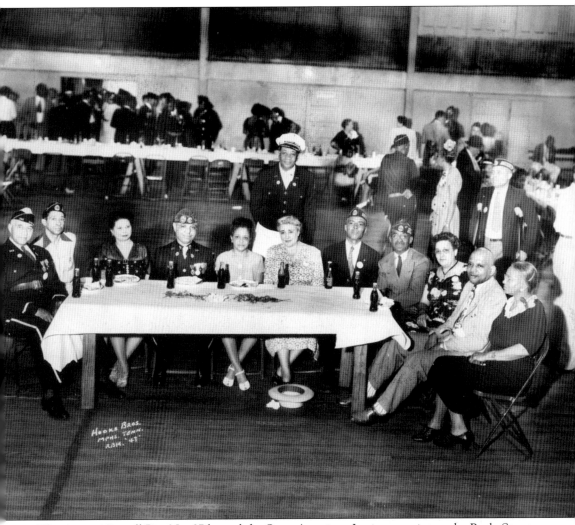

The Autress Russell Post No. 27 hosted the State American Legion meeting at the Beale Street Auditorium in July 1947. The auditorium continued to be an important center for community life even though the city had changed the name of the park and the auditorium to Beale Street Park and Auditorium in 1941. The old name was not restored until 1956. (Memphis Room.)

Beale Street has always been a center for the city's black newspapers. In the 1890s, journalist Ida B. Wells published the *Free Speech and Headlight* from the basement of Beale Street Baptist Church. In the early 1900s, newsstands on the street carried African American papers like the *Evening Striker*, the *Bluff City News*, the *Memphis Times*, and the *Memphis Moon*. From its offices on Beale Street, the *Memphis World* was considered the most militant and aggressive of the papers in the 1930s and 1940s, but by the 1950s the *World* took a more gradualist approach to racial issues. John Sengstacke's *Tri-State Defender*, sister newspaper to the *Chicago Defender*, began publication in the early 1950s. Under editor L. Alex Wilson, the *Defender* aggressively tackled civil-rights stories and published gripping photographs by Memphian Ernest Withers. (Memphis Room.)

Three

POLITICAL AND CIVIC LIFE

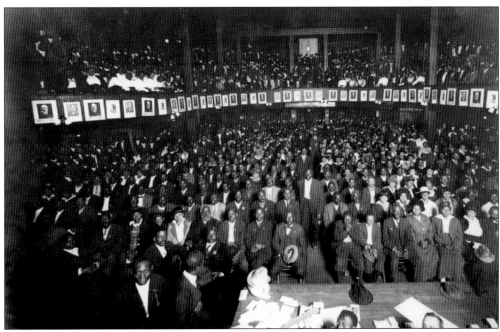

The Lincoln League held its first meeting on February 12, 1916, at Church's Park and Auditorium. The primary goals of the league, organized and financed by Robert R. Church Jr., were to organize and register black voters in Memphis and Shelby County and to monitor a movement for constitutional change in Tennessee that would make it more difficult for blacks to vote. The Lincoln League had registered 10,000 voters by October 1916 and ran black candidates for state representative, state senator, and U.S. congressman. Although none of them won office, the league demonstrated the strength of the black vote in Memphis and Shelby County. (Mississippi Valley Collection.)

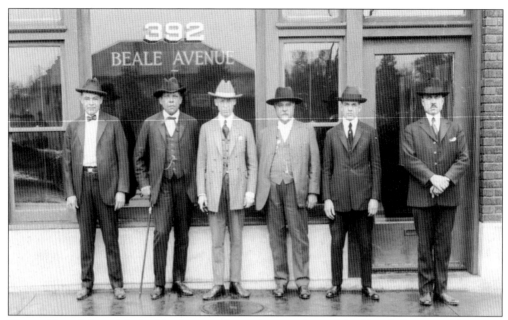

Pictured from left to right in this photograph are the organizers of the Lincoln League of America: Robert Church Jr., Henry Lincoln Johnson, Roscoe Conkling Simmons, Walter Cohen, John T. Fisher, and Perry Howard. In 1919, Simmons was elected president of the national league, and Church chaired the executive committee. Church also focused his attention on the Memphis chapter of the NAACP and the Republican Party. (Mississippi Valley Collection.)

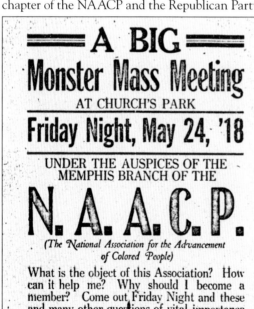

The Memphis chapter of the National Association for the Advancement of Colored People (NAACP) was the first branch established in the South. It had 53 members when it was chartered in June 1917, and over a thousand by 1919. Like the national organization, the chapter supported passage of federal anti-lynching legislation and abolition of the poll tax.

Robert Church Jr. was a leader among black Republicans on the local, state, and national level. He is shown here on the left with Oscar De Priest of Illinois, the first African American elected to the U.S. Congress in the 20th century and the first-ever Northern black congressman. De Priest was elected in 1928, 27 years after North Carolina congressman George L. White left office, and served until 1935. (Mississippi Valley Collection.)

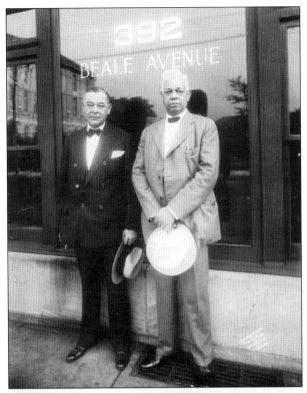

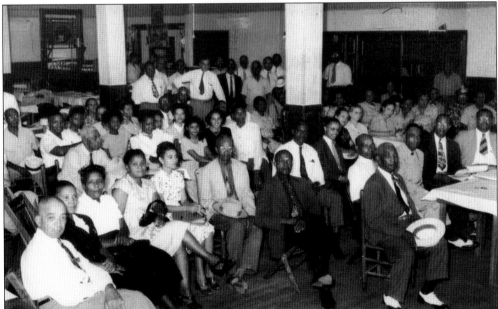

Although limited in their choices of candidates, black Memphians maintained active political involvement throughout the 20th century. Beale Street Auditorium was the site of meetings like the one pictured above. Involvement in the Republican Party remained strong and, with the Republican national administrations of the 1920s, Robert Church was able to deliver considerable federal patronage. (Memphis Room.)

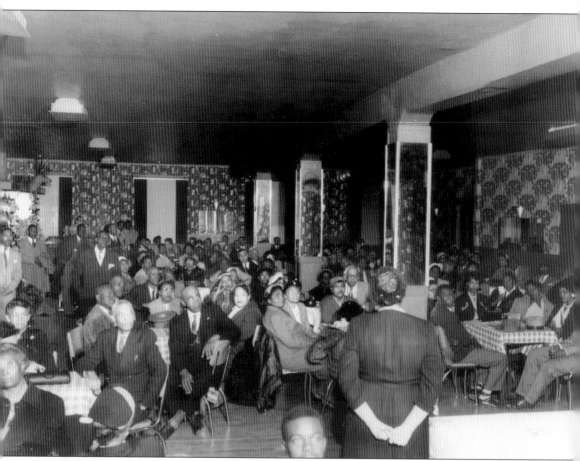

There was no black voting block in Memphis that could be guaranteed to either party. Instead, black Memphians voted their own best interests. In the 1930s, Dr. J. E. Walker, founder of Universal Life Insurance Company, organized the Independent Business and Civic Association, an African American Democratic club. Democratic control of national government during the 1930s and 1940s and Walker's influence in the Memphis NAACP cemented his challenge to Church's influence. (Memphis Room.)

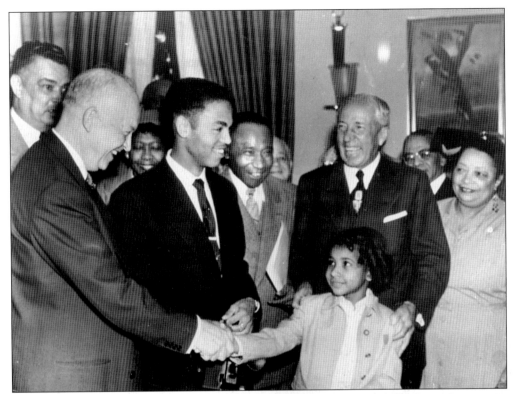

In the 1952 presidential election, George W. Lee, undisputed leader of the black Republicans in Memphis and "Mayor of Beale Street," campaigned for Dwight Eisenhower. Using the connections of the old Lincoln League, Lee put 150 paid workers in the city's black voting districts and focused attention on differences between Democrats and Republicans on issues of racial equality. During Eisenhower's campaign visit to Memphis, Lee pressured the state Republican chairman into allowing Eisenhower to shake hands with blacks. Eisenhower is shown in the first photograph greeting Lee's daughter, Gilda. Lee also had Benjamin Hooks (shown with Richard Nixon) and Orrin Pickett on the welcoming committee at the airport. When Eisenhower's limousine went down Beale Street, he personally greeted Lee. (Memphis Room.)

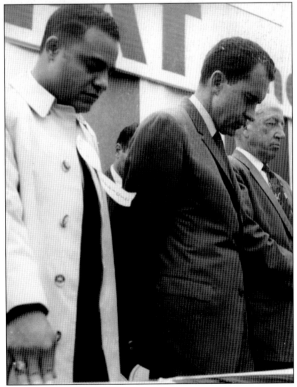

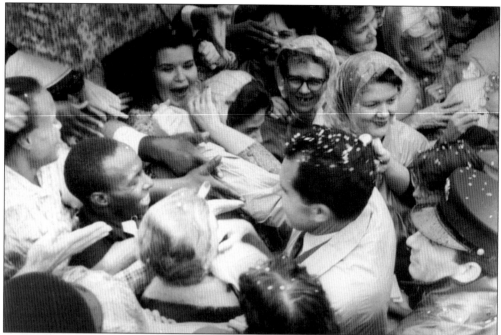

Richard Nixon visited Memphis during his 1960 presidential campaign. Nixon drew large crowds in the black community and was applauded for insisting on a civil rights plank in the Republican platform. But Nixon, like Eisenhower, could not reclaim the city's black vote—especially after he failed to respond to Lee's suggestion that he issue a statement about the imprisonment of Martin Luther King in a Georgia civil-rights demonstration. (Memphis Room.)

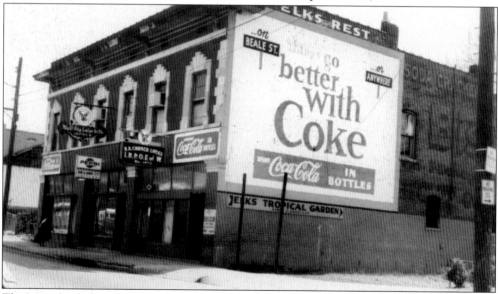

The Memphis lodge of the Improved Benevolent and Protective Order of Elks of the World was organized on June 26, 1906. The lodge drew its membership from local black elites like Robert Church, H. H. Pace, James R. Wright, and George W. Lee. Lee served as grand commissioner of education and was considered the organization's finest orator. The Elk's lodge on Beale Street was named after Robert Church. (Memphis Room.)

In line with Lee's national position as commissioner of education of the Improved Benevolent and Protective Order of Elks of the World (IBPOEW), the Memphis lodge sponsored adult education programs to combat illiteracy. Lee believed illiterates should be taught to read the Bible and the Constitution, to write their names, and should know the fundamentals of voting. The lodge also sponsored scholarships and oratorical contests and, in 1938, they established a Christmas basket fund. Members collected food items, loaded them into dump trucks, and delivered them to needy families like the one shown in the photograph below. (Memphis Room.)

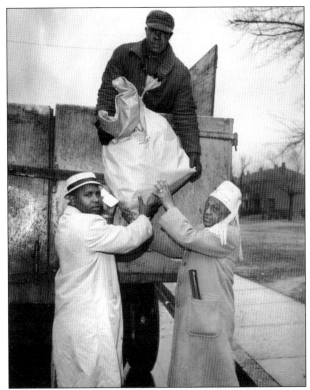

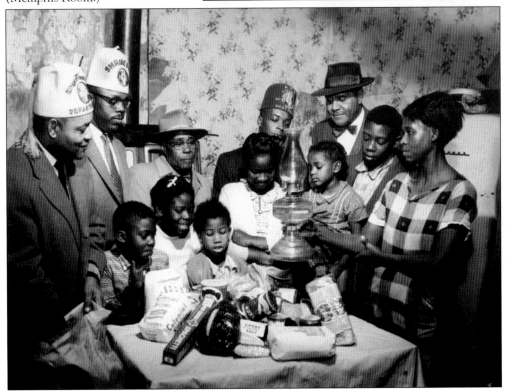

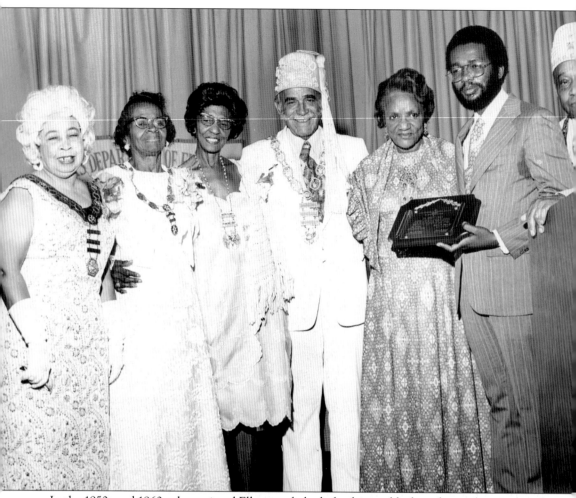

In the 1950s and 1960s, the national Elks awarded scholarships to black students who integrated formerly all-white schools. Lee encouraged the national body to fund these awards by launching a $100,000 "crusader's program for freedom." Although they raised less than half this sum, the group gave college scholarships to the nine black students who integrated Little Rock Central High School and to other student leaders. In this photograph, Ernest Green, the first of the Little Rock Nine to graduate, receives his scholarship. (Memphis Room.)

Closer to home, the Elks presented prizes and monetary awards to local winners in essay and oratorical contests. These competitions reflected George W. Lee's commitment to achievement in two areas in which he had long demonstrated excellence—writing and speaking. Contests were held in the African American grammar, junior high, and high schools, and the winners proudly displayed the fruits of their victories. (Memphis Room.)

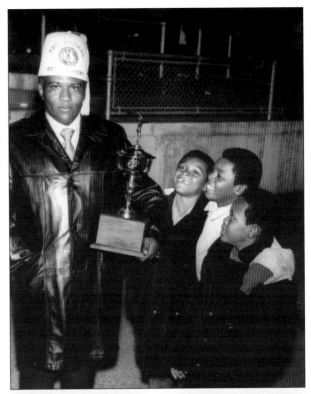

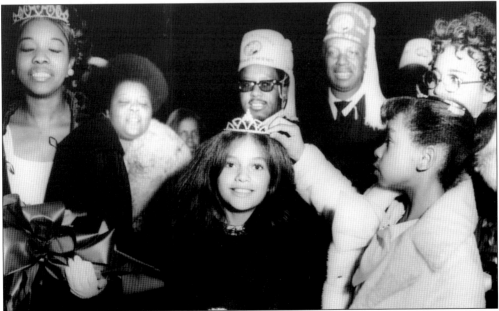

The Elks also sponsored the annual Blues Bowl football game. The games featured teams from Memphis's African American public and parochial high schools and were highlights of the school year. The games also symbolized an important connection between the Elks, Memphis's blues music tradition, and the community. In this photograph, the unidentified winner of a Miss Blues Bowl competition has her crown straightened by a well-wisher. (Memphis Room.)

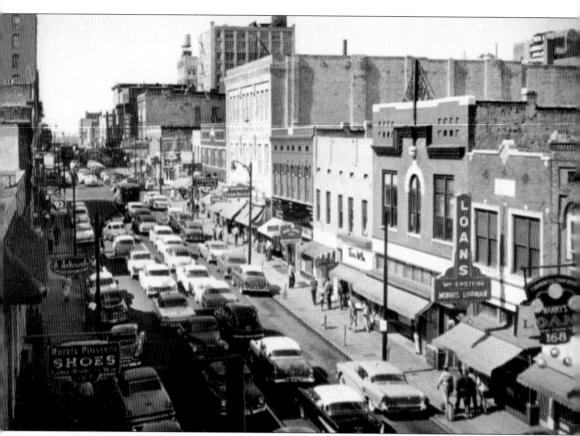

Despite the turmoil of economic depression, two World Wars, and shifting political alignments, Beale Street remained an important commercial, civic, and entertainment magnet for black Memphians. Whether they lived on the nearby streets, avenues, or alleys or came downtown from Douglass Park, Orange Mound, or other neighborhoods, young and old still found their way to Beale Street. It was their Main Street, and nothing demonstrated this more than the parades and carnivals of the Cotton Makers' Jubilee.

Four

THE COTTON
MAKERS' JUBILEE

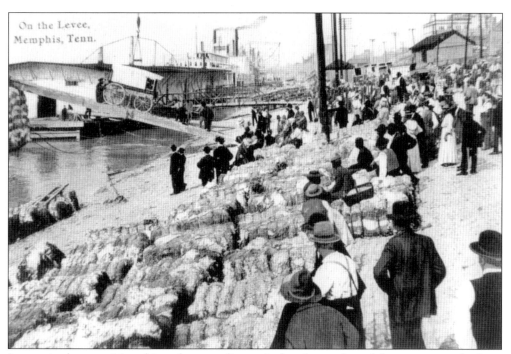

Interaction between Memphis and surrounding agricultural areas shaped the economy and culture of the city. Post–Civil War migrations brought growing numbers of rural blacks to Memphis, but these migrations slowed during the Great Depression of the 1930s. For migrating blacks, Memphis was an attractive alternative to the rural pace of life, but most soon realized that they were simply trading the cotton fields of the Mississippi delta for an urban cotton-based economy. (Memphis Room.)

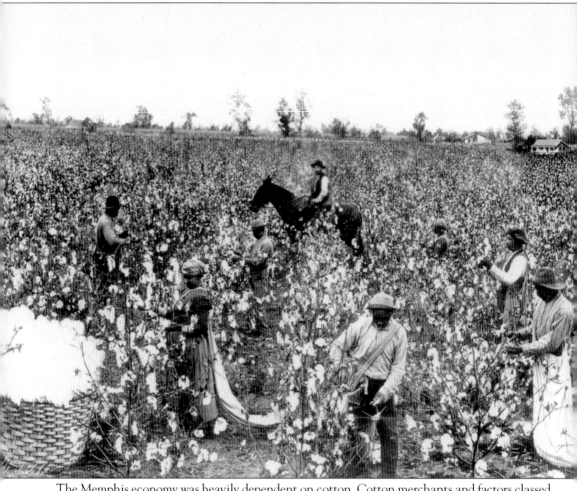

The Memphis economy was heavily dependent on cotton. Cotton merchants and factors classed and sold the crop and financed delta farms and plantations. Local stores relied on rural customers. The place that African Americans had in this economy in the mid-20th century was much the same as it had always been. They were the "cotton-makers" who planted, picked, and loaded this "white gold" on steamboats headed for domestic and foreign markets. (Memphis Room.)

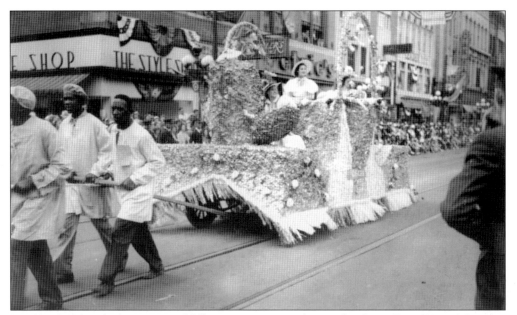

In 1931, faced with the impact of falling cotton prices during the Great Depression, Memphis businessmen developed the Cotton Carnival to celebrate cotton. A highlight of the Cotton Carnival was the arrival of the king and queen at the city's steamboat wharf, followed by a grand parade that started at Ellis Auditorium and proceeded down Main Street, then over to Second Avenue and back to the auditorium. (Memphis Room.)

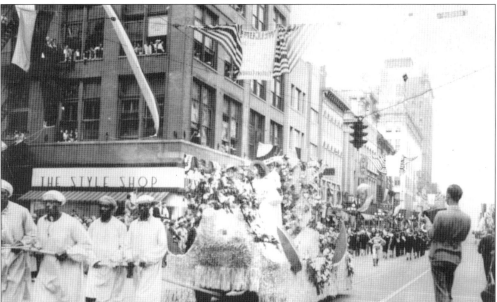

Except for the black men who attended the king and queen as they left the steamboat or pulled the floats down Main Street or the bandanna-clad black "aunties" or "mammies" who sat on bales of cotton that lined the parade route, African Americans had no place in the celebration of cotton. When Ethel Venson, wife of a prominent black dentist, asked her five-year-old nephew how he enjoyed his first parade, he replied that he didn't like it because "all the Negroes were horses." (Memphis Room.)

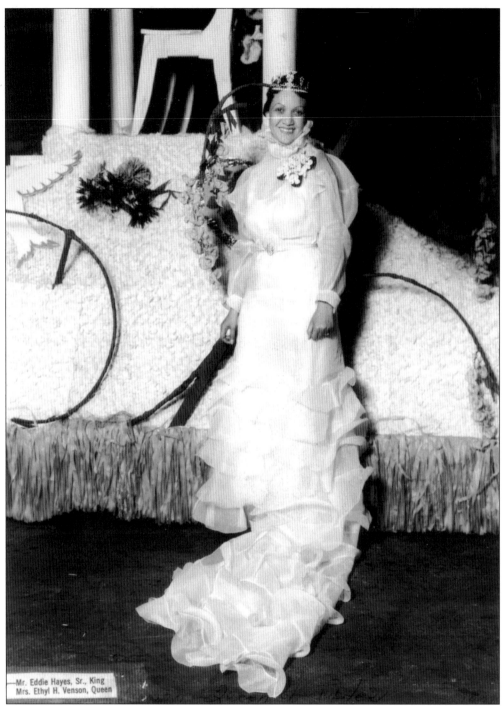

-Mr. Eddie Hayes, Sr., King
Mrs. Ethyl H. Venson, Queen

In response, Venson's husband, Dr. R. Q. Venson, with support from friends at the Autress Russell American Legion Post, organized the Beale Street Cotton Makers' Fiesta. The weeklong celebration included the coronation of junior and senior royalty, parades, beauty contests, baseball games (by Negro League teams at black-owned Martin Stadium), and a carnival midway. This 1936 photograph shows the fiesta's first queen, Ethel Venson. (Pink Palace.)

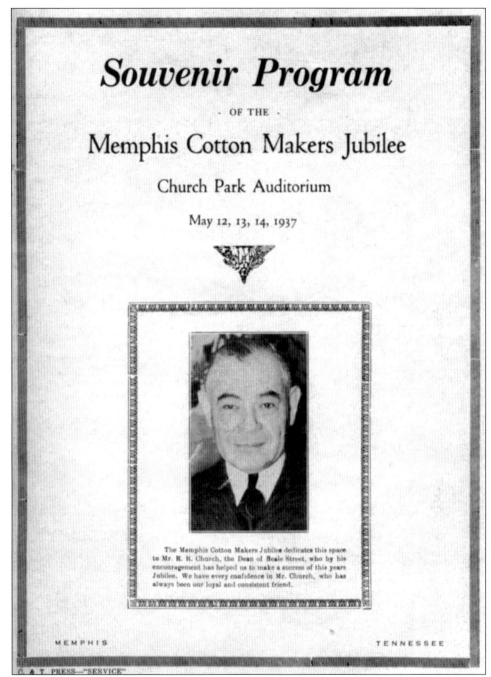

Souvenir Program

- OF THE -

Memphis Cotton Makers Jubilee

Church Park Auditorium

May 12, 13, 14, 1937

The Memphis Cotton Makers Jubilee dedicates this space to Mr. R. R. Church, the Dean of Beale Street, who by his encouragement has helped us to make a success of this years Jubilee. We have every confidence in Mr. Church, who has always been our loyal and consistent friend.

MEMPHIS TENNESSEE

C. & T. PRESS—"SERVICE"

In 1937, organizers changed the name of the event to the Cotton Makers' Jubilee and dedicated their program to Robert R. Church Jr., the "Dean of Beale Street." Jubilee royalty came from Memphis's black professional and business elite. The 1937 king was Thomas H. Hayes Jr. of Hayes Funeral Home, and the queen was Annie Hickman, wife of Dr. S. B. Hickman. Floats were purchased and sponsored by black and white businesses. W. C. Handy, a personal friend of Robert Church, R. Q. Venson, and George W. Lee, often returned to Memphis to participate in the jubilee. (Memphis Room.)

Twenty-five thousand people watched as the 1938 parade proceeded down Beale Street to Handy Park. The 20 floats illustrated connections to and life along four great rivers—the Mississippi, the Nile, the Congo, and the River Jordan. Dancers performed the "Jubilee Dip," created by a Beale Street dance instructor before a reviewing stand. Speeches were given by superintendent of schools E. C. Ball, Mayor Watkins Overton, attorney Bailey Walsh (representing the Memphis Cotton Carnival), and Dr. R. Q. Venson, president of the Cotton Makers' Jubilee. There was also a special place reserved for "white visitors" who wanted to watch the parade. The king, Ossie L. Moss, was a bellhop at the Peabody Hotel, and the queen, Ann Holden Martin, was a senior at Booker T. Washington High School and a beautician at Nudy's Beauty Shop. (Memphis Room.)

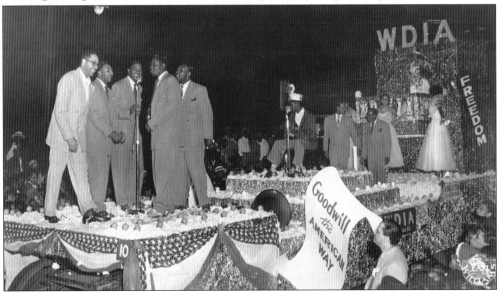

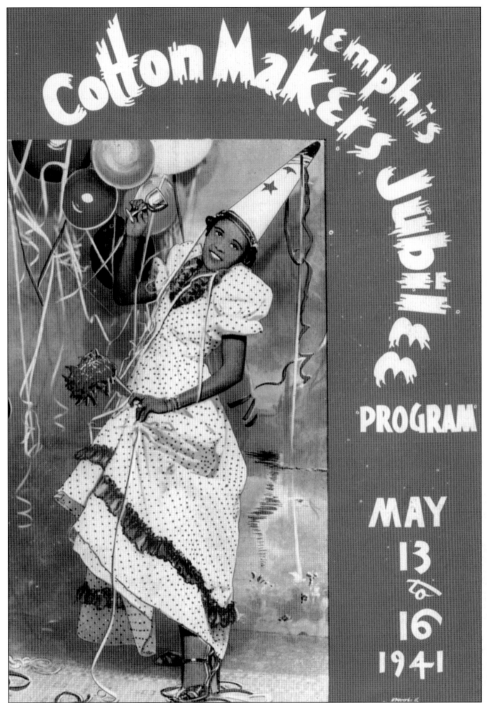

The cover image for the 1941 program became the signature image for the Cotton Makers' Jubilee for the next 40 years. The method of selecting the king and queen also changed in 1941. Contestants sold tickets to a radio-stage show held at Ellis Auditorium. Each ticket entitled the holder to vote for the royalty. Ballots were counted after a radio broadcast featuring contestants in a quiz program. (Memphis Room.)

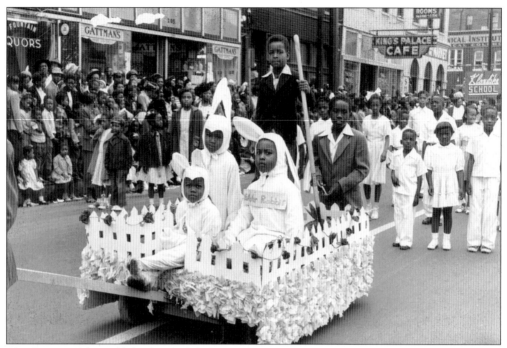

The Cotton Makers' Jubilee featured three parades: a coronation parade, a children's parade, and a grand jubilee parade. Photographer Earl Williams took these pictures of viewers lining Beale Street to watch costumed participants in a children's parade. Grammar schools, nurseries, kindergartens, and other groups sponsored floats like these two, the top one depicting "MacArthur Rabbit" and the bottom one tying the fairyland theme to demands for recognition that "I Am An American." Children's parades also featured the jubilee's junior royalty. (Mississippi Valley Collection.)

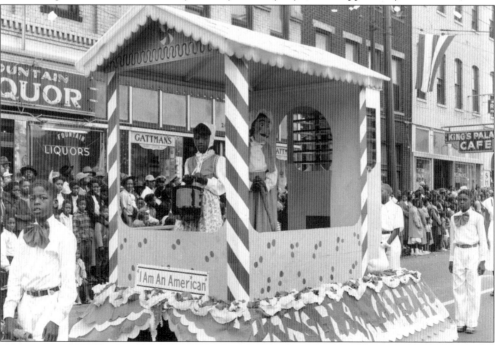

In 1941, the jubilee inaugurated a contest for Miss Jubilect. The Jubilect was a musical extravaganza featuring bands from Dixie Homes and Foote Homes Tenant Associations, Manassas and Booker T. Washington High Schools, Melrose and Douglass Junior High Schools, and La Rose and Porter Grammar Schools. Tickets were sold for this competition, and white Memphians could also purchase these and vote for Miss Jubilect. (Mississippi Valley Collection.)

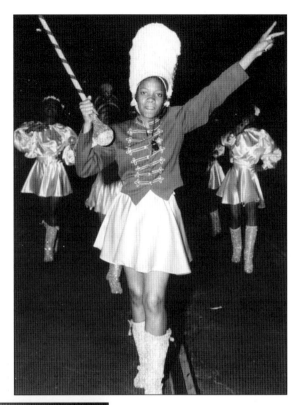

Manassas High School majorette Gloria Diggs performs in the 1948 Jubilee coronation parade. The parade went down Beale Street to Wellington and Iowa Streets and over to Martin Stadium. Majorettes from Booker T. Washington High School, clad in their green and yellow costumes, and silver-skirted baton twirlers like Diggs from Manassas danced backward, forward, and sideways to the music of their school bands. The jubilee was most successful from 1948 to 1958. (Mississippi Valley Collection.)

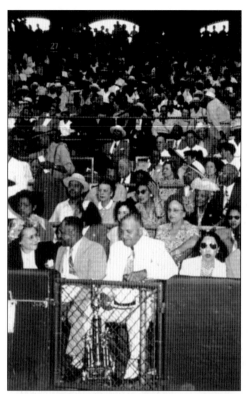

Thousands watched as the crowing of 1948 king and queen at Martin's Stadium. The coronation ceremony included a ritual to honor those killed in World War II. There had been no jubilee celebrations during the war. This photograph may have been taken at the event or at a baseball game held in the stadium. Dr. Martin is the man on the front row holding onto his hat. (Pink Palace.)

Pictured here is 1950 Jubilee royalty Spencer Smith, a school principal, and Lee Eleanor Reed, a secretary at Universal Life Insurance Company. The Spirit of Cotton, Bettie Jean Johnson of Philander Smith College in Little Rock, Arkansas, was sponsored by Daisy Bates. Seven years later, Bates led nine black students in the desegregation of Little Rock's Central High School. (Pink Palace.)

This photograph shows the 1951 Jubilee royalty King Johnson Saulsberry and Queen Ollie Dortch. Nat D. Williams observed that white Memphians refused to use titles of respect when referring to black Memphians, but felt comfortable using the "highest title of respect ever coined when they referred to Jubilee royalty." (Pink Palace.)

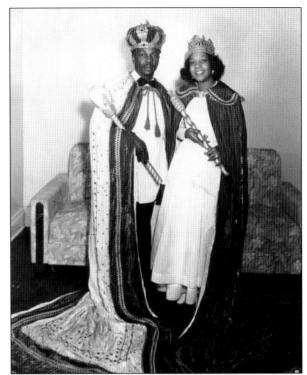

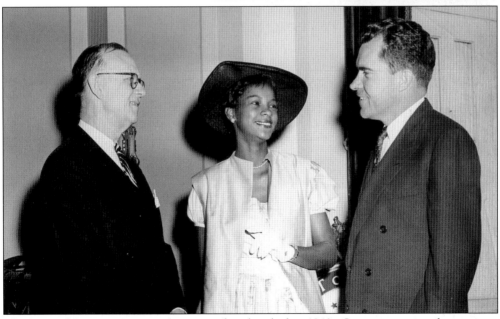

The Spirit of Cotton competition was introduced in the late 1940s. Contestants came from cotton-producing states across the country. They attended charm clinics and training sessions before one was chosen to represent the jubilee in a national and international tour. This photograph shows the 1955 Spirit of Cotton, Arkansan Joyce McClinton, meeting with Congressman Brooks Hayes of Arkansas and Vice Pres. Richard Nixon. McClinton's six-week tour also included stops in Cuba and Haiti. (Pink Palace.)

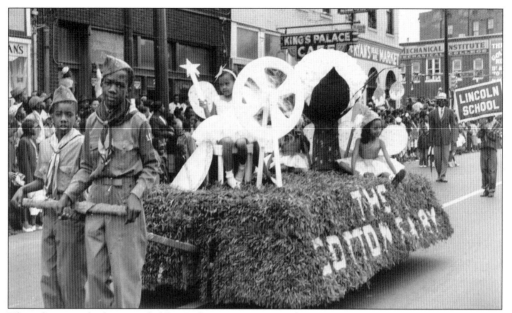

This photograph shows a children's float interpreting the 1940 Cotton Makers' Jubilee theme, "King Cotton in the World of Tomorrow." The jubilee was incorporated in 1940 under Tennessee law with Dr. R. Q. Venson as chairman of a board of directors that included 40 members from the African American community. The jubilee continued to enjoy a close financial association with the white Cotton Carnival. (Pink Palace.)

A *Commercial Appeal* columnist reported that the 1964 parade "blew the lid off Beale Street with a blast that probably would have given stiff competition to the horn of Gabriel." Crowds stood 20 deep along Beale Street from Main Street to Wellington Street. Above the street, onlookers perched on ledges, fire escapes, and building tops and in windows to catch a glimpse of the Grand Parade. This was the biggest parade to date in the history of the Cotton Makers' Jubilee. (Pink Palace.)

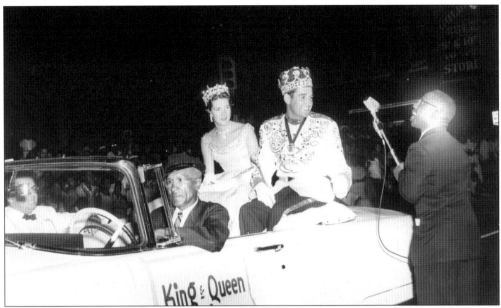

Nat D. Williams greets Cotton Carnival royalty during the Cotton Makers' Jubilee Parade on Beale Street. Royalty from the white celebration appeared in the parades or as platform guests of the jubilee's black royalty, but the jubilee's royalty did not participate in the white celebration. The two events remained segregated until 1981. Some African Americans had opposed the jubilee from its beginning in 1935, and in the 1960s, the NAACP and student activists picketed jubilee events. (Pink Palace.)

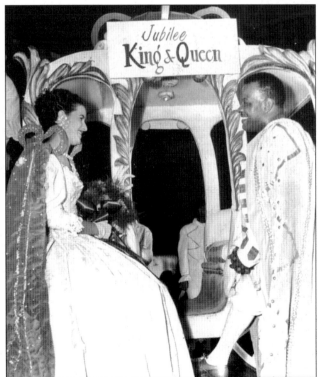

In 1957, the Cotton Makers' Jubilee king Richard "Cane" Cole of Memphis and queen Dorothy Brown of Hernando, Mississippi, arrived at their coronation in a golden coach drawn by some spirited brown horses. The horses almost got away from their handlers on three occasions. The coronation parade was followed by a coronation ball at the Beale Street Auditorium. A masquerade ball at the auditorium capped the Grand Jubilee celebration later that week. (Mississippi Valley Collection.)

Beginning in the 1950s, the Cotton Makers' Jubilee had a carnival midway at Church's Park. The midway included food stands, rides, and entertainment at the auditorium. Performers were provided by Wallace Brothers Shows. This photograph shows the midway in 1972. (Mississippi Valley Collection.)

This 1982 photograph depicts a new era in the jubilee's history. In 1981, the jubilee became a krewe and a full partner in the reconstructed Great River Carnival. Krewes are groups that organize and participate in the carnival (similar to krewe participation in Mardi Gras). Krewes pay equal fees to participate in the carnival and are therefore considered equal partners regardless of how long they have been involved. The changes reflected social, political, and economic developments in Memphis following the assassination of Martin Luther King and urban development projects in the 1970s. In 1985, Clyde Venson, nephew of R. Q. Venson, reinvented the jubilee by changing the name to the "Kemet" Jubilee. (Pink Palace.)

Five

THAT MEMPHIS SOUND

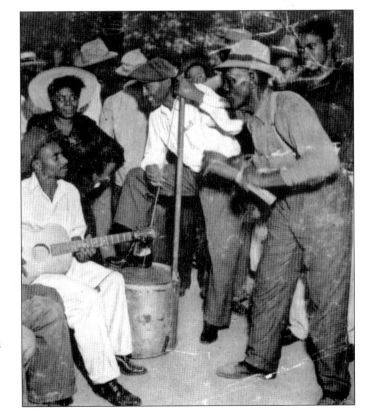

Beale Street has always been a place of music. Jug bands, like this one playing on a street corner in 1949, used a variety of rudimentary instruments. Blowing across the mouth of a whiskey jug helped keep the rhythm, along with strumming on a single-string washtub bass. Guitars, banjos, mandolins (often homemade), and rhythmic clapping and stomping rounded out the tune. (Memphis Room.)

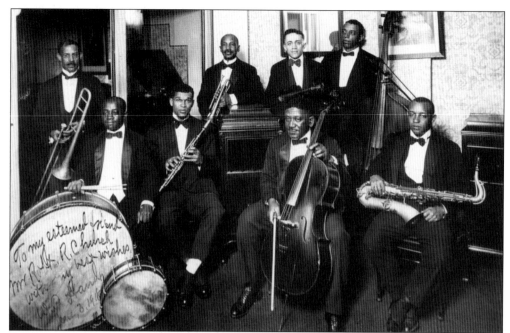

Coronet player and bandleader William Christopher Handy came to Beale Street from Alabama in the early 20th century. His band traditionally played orchestral music until he was influenced by the Memphis sound played by jug bands and bluesmen. He composed a campaign song for mayoral candidate E. H. Crump in 1909, which Handy published in 1912 as "The Memphis Blues." (Mississippi Valley Collection.)

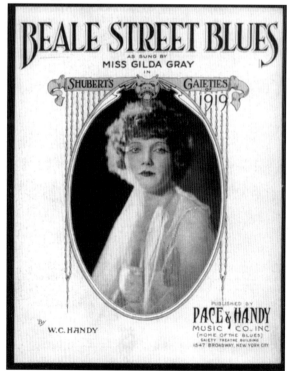

Handy and his partner, Harry Pace, composed such hits as "Yellow Dog Rag," "Joe Turner Blues," and "St. Louis Blues," which was an immediate hit and recorded by many artists for many years, including Bessie Smith and Louis Armstrong. In 1917, Handy published the "Beale Street Blues," firmly establishing the street as the home of the blues. (Memphis Room.)

Lt. George W. Lee, political activist and Beale Street promoter, proudly displays a poster with sheet music from "The Memphis Blues," "St. Louis Blues," and "Beale Street Blues." (Memphis Room.)

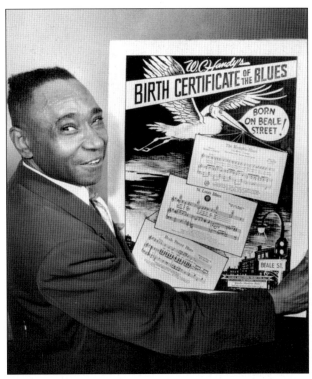

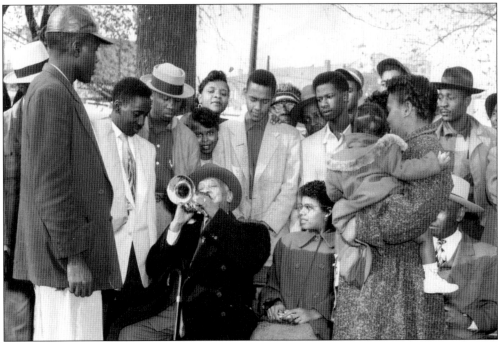

A park at Beale and Hernando was dedicated to W. C. Handy in 1931. Although he was no longer a resident of Memphis, having relocated to New York in about 1917, Handy returned to the city every year for the high school Blues Bowl, featuring the football teams of two black high schools. (Mississippi Valley Collection.)

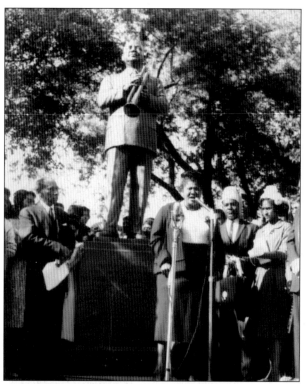

After Handy's death in 1958, the city commissioned a statue of the famous musician to be placed in Handy Park on May 1, 1960. Gospel singer Mahalia Jackson performed at the ceremony. Lt. George W. Lee is on the left. (Memphis Room.)

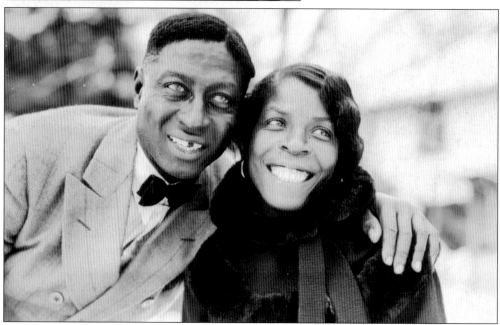

From the early 20th century, blues singers and musicians like Leadbelly performed regularly in Beale Street clubs. Born Huddie William Ledbetter, Leadbelly had a remarkable music career. In and out of prison during the 1920s and 1930s, he was "discovered" by musicologist Alan Lomax in the 1930s and began recording. He was later befriended by folk singers Woody Guthrie and Pete Seeger and recorded hundreds of songs before he died in 1949. (William Bearden.)

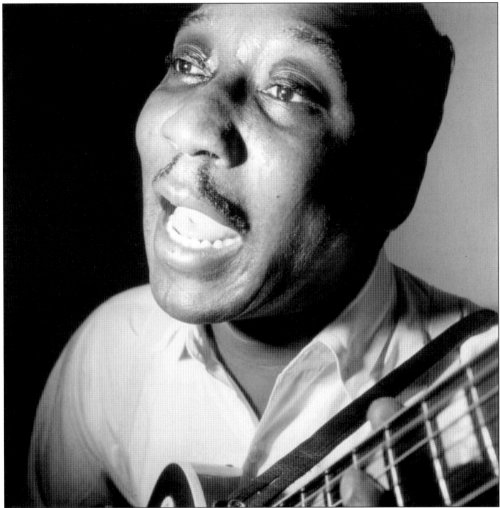

Muddy Waters personified the Delta blues. Born in Rolling Fork, Mississippi, as McKinley Morganfield, Muddy Waters began recording in 1943. He was yet another bluesman discovered by Alan Lomax as he recorded the music of the Delta for the Library of Congress in the 1930s and 1940s. (William Bearden.)

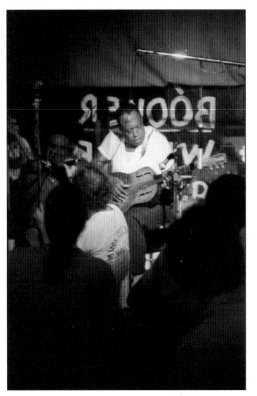

Bukka White was another bluesman whose hard living and experiences with poverty, hard work, and conflict with authority were reflected in his music. Bukka served time and made a recording in Parchman Prison in the 1930s. Rediscovered during the folk-blues revival of the late 1960s, he revived his career and continued to play festivals (shown here playing in Memphis in 1969) until his death in 1977. (Douglas Cupples.)

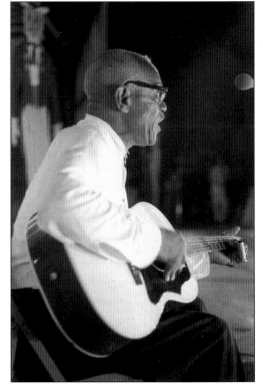

Furry Lewis was one of the longest-lasting blues stars on Beale Street. Discovered by W. C. Handy, he performed frequently during Beale Street's heyday of the 1920s–1940s. His career revived after becoming famous for the second time in the late 1960s. A virtuoso on the slide guitar (note the bottle slide on his left hand), he is shown playing here at the 1968 Memphis Blues Festival. Before he died in 1981, he opened for the Rolling Stones and appeared on Johnny Carson's *Tonight Show*. (Douglas Cupples.)

Individual performers and vaudeville shows traveling the so-called "Chitlin' Circuit" appeared in numerous venues on Beale Street. Shows in the 1930s included the Black Patti Troubadours, starring Madame Sissieretta Jones; the Smart Set with S. H. Dudley, advertised as "The Greatest Colored Show on Earth;" and this one, Beale Street Mama with an "All-Star Colored Cast." (Janann Sherman.)

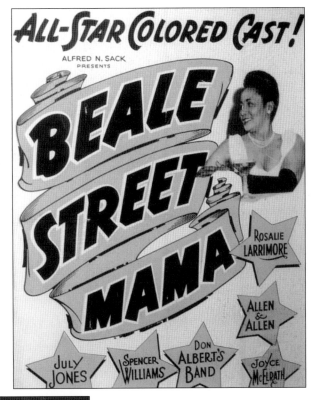

Perhaps the show's title came from "Beale Street Mama," published in 1923. It begins: "Mamie Neal, down on Beale, gave her papa the air. Left him cold, got him told, that she didn't care. Poor Joe, her beau, looks just like he would die. If you're near him, you can hear him, start this mournful cry: Beale Street mama, why don't you come back home?" (Beverly Bond.)

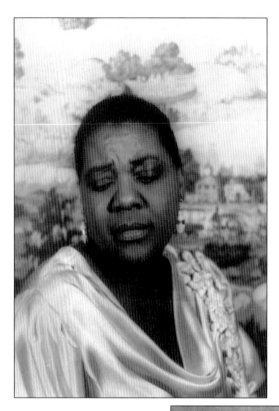

Bessie Smith was one of the most popular and successful blues singers in the 1920s and 1930s. Bessie began performing on the streets of her hometown, Chattanooga, as an adolescent. She signed with Columbia Records in 1923 and produced hits like "Down Hearted Blues" and W. C. Handy's "St. Louis Blues" and "Gimmie a Pigfoot." Bessie was much beloved on Beale Street during its heyday. She died in a car accident while traveling from a concert in Memphis to Clarksdale, Mississippi, in 1937. (William Bearden.)

Willie Mae "Big Mama" Thorton toured with Sammy Green's "Hot Harlem Revue" as it traveled the South in the 1940s. She is best known for her growling rendition of "Hound Dog" recorded in 1953, a big hit on the rhythm-and-blues charts. Three years later, Elvis Presley smoothed it out and turned it into one of rock and roll's first big hits. (Memphis Room.)

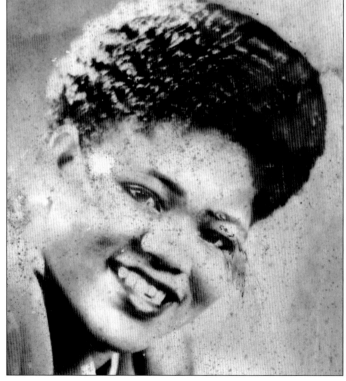

BLUES CLASSICS BY
MEMPHIS
MINNIE

IN MY GIRLISH DAYS
BLACK RAT SWING
LONESOME SHACK BLUES
IT'S HARD TO PLEASE MY MAN
I'M SO GLAD
NOTHING IN RAMBLING
AND MY CHAUFFEUR BLUES
JOE LOUIS STRUT

IT'S HARD TO BE MISTREATED
IAN YOU WON'T GIVE ME NO MONEY
BOY FRIEND BLUES
MOONSHINE
IY BABY DON'T WANT ME NO MORE
WHEN THE LEVEE BREAKS
YOU GOT TO MOVE - Pt. 1

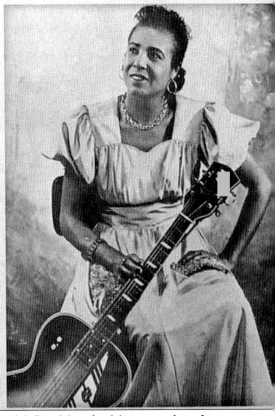

Among the best blues women was "Memphis Minnie" McCoy. Memphis Minnie was born Lizzie Douglas in Algiers, Louisiana, in 1897. Before she was 10, her family moved to Walls, Mississippi, just south of Memphis, and as "Kid Douglas" she played banjo and guitar on Beale Street corners. Minnie was discovered in 1929 by a talent scout from Columbia Records while playing in a Beale Street barbershop. She was an inspired guitarist; male musicians gave her their highest praise: "she played like a man." Memphis Minnie recorded over 100 songs during her 30-year career. Some of them are listed here. Others included "Bumble Bee," "Cherry Ball Blues," "Lay My Money Down," and "I'm Selling My Pork Chops (but I'm Giving My Gravy Away)." (William Bearden.)

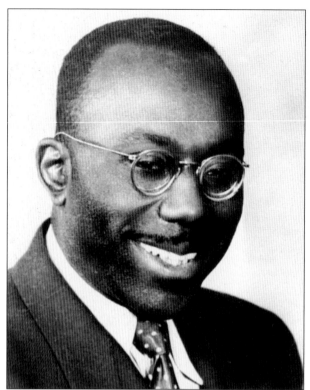

Nat D. Williams was the first black man in the South to become a regular host of a radio show. He was a teacher at Booker T. Washington High School and a popular newspaper columnist for the *Memphis World* when radio station WDIA took the giant leap into black programming in 1948. His show was called the *Tan Town Jamboree*, which he opened with "Well, yes-siree, it's Nat D. on the Jamboree, coming at thee at 73 [on the dial] WDIA." He was also emcee for Amateur Night every Tuesday at the Palace Theater. (Mississippi Valley Collection.)

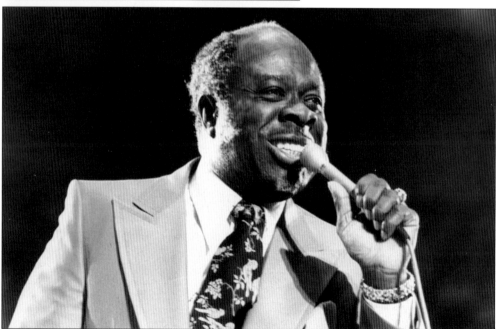

The Palace Theater was the Memphis equivalent of the Apollo Theater in Harlem. On Amateur Night, contestants clamored for the chance to please the tough hometown crowd and win the prize money: $5 for first place, $3 for second, $2 for third. Rufus Thomas was Nat D. Williams's sidekick for the show. (Mississippi Valley Collection.)

The Palace Theater's amateur show was raucous and high-spirited. Sometimes the worst acts were the hit of the show. If performers were bad enough to be booed by the crowd, they were supposed to leave the stage. If they did not, the Lord High Executioner (Rufus Thomas) would leap from the wings and fire blanks at them from his pearl-handled pistol. (Mississippi Valley Collection.)

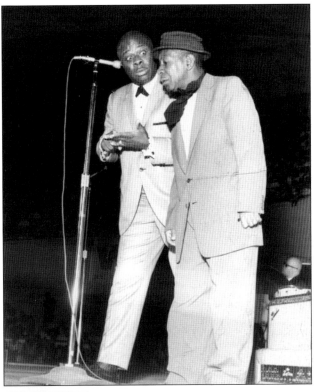

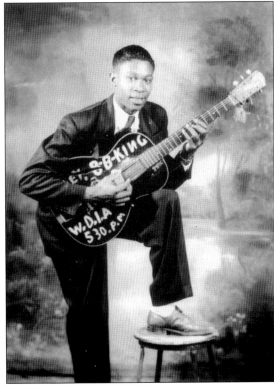

This inspired craziness lasted some 30 years at the Palace and launched some of the biggest names in black entertainment. Most famous was a skinny blues singer from Indianola, Mississippi, named Riley King. He suffered the crowd's boos and was shot by the executioner, but he kept coming back. He made his way to WDIA, where he became so popular that he soon received his own show. Initially billed as the Beale Street Blues Boy, the nickname was shortened to Blues Boy and then to simply B. B. He made his first recording at the WDIA studio and continued his radio show for several years while traveling with his band. B. B. King went on to superstardom and, since 1991, has his own blues club on Beale Street. (Mississippi Valley Collection.)

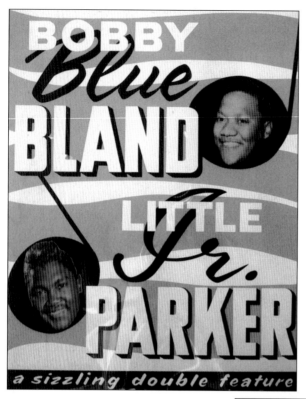

Posters from Beale Street in the 1950s reflect the excitement of Memphis music: a double feature of Bobby Blue Bland, who had such hits as "Turn on Your Love Light" and "Yield Not to Temptation" and Little Junior Parker, protégé of Sonny Boy Williamson and one of the finest harpists around. (Memphis Room.)

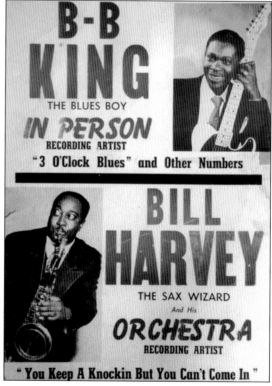

B. B. King and Bill Harvey played regularly at Club Handy at the corner of Beale and Hernando Streets. Sunbeam and Ernestine Mitchell owned the hotel upstairs where musicians stayed and feasted on Ernestine's famous chili. Originally the club was called the Domino Lounge, but Mitchell changed it to Club Handy after its namesake died. Jazz and blues greats including Lionel Hampton, Dizzy Gillespie, and many others performed there. Bill Harvey led the house band. (Memphis Room.)

These street musicians provided an impromptu concert outside 197 Beale Street, the old Beale Street Market. Dentist O. B. Braithwaite and lawyer A. A. Latting had offices on the upper floors of the building, and next door was the King's Palace Café. This photograph was taken in 1954, the year that the Forty Minute Cleaning Company replaced the market at this site. (Mississippi Valley Collection.)

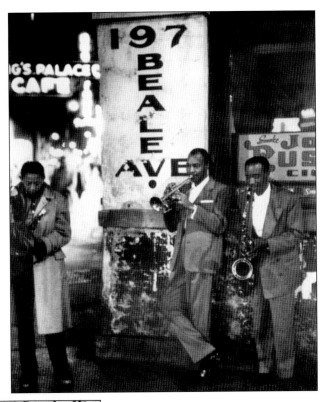

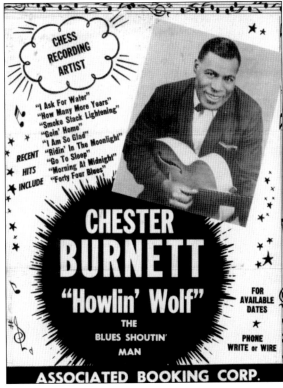

Chester "Howlin' Wolf" Burnett was one of the first to record for Sam Phillips's Sun Studio in the early 1950s, when the blues were called "race music." Phillips remarked, "When I heard Howlin' Wolf, I said, 'This is for me. This is where the soul of man never dies.'" At over 6 foot 4 inches and some 300 pounds, Howlin' Wolf was a significant presence on stage. In the 1960s, he opened for the Rolling Stones and enjoyed international acclaim. He died in 1976. (Memphis Room.)

Beale Street's clubs and juke joints were focal points for what George W. Lee called "a gay and raucous night life. The music was hot, the beer was cold and Beale Street was jumping." Most of the crowds were black, but on Thursday nights in the 1930s, white patrons lined the street in "high-powered cars, overalls, and Fords to see the scantily clad brown beauties dancing across the stage in the midnight show at the Palace." Beale Street's heyday was the 1930s through the 1950s, but this was not to last. (Pink Palace.)

Robert Henry, one of the best-known promoters on Beale Street, is pictured outside the Daisy Theater in the 1960s. Henry went to work at the Daisy in 1911 and later, as owner of Robert's Recreation Parlor, booked big bands like those of Fats Waller, Jimmy Lunceford, Cab Calloway, and Count Basie into Church's Park Auditorium. In this photograph, Henry, who died in 1978, reflects on the closing of the Daisy and other theaters and the migration of the once-thriving businesses to other parts of Memphis. (Mississippi Valley Collection.)

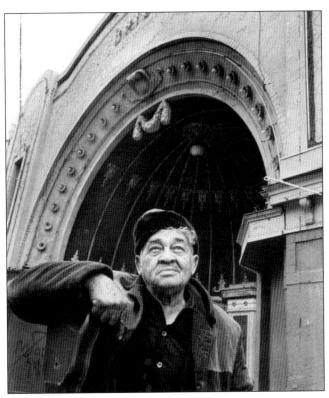

Beale Street also suffered in 1968 from a series of altercations between police and marchers in solidarity with striking Memphis sanitation workers. The April 1968 assassination of Dr. Martin Luther King Jr. at the Lorraine Motel nearby sealed the fate of Beale Street. Not long afterward, the bulldozers of urban renewal moved in. From 1968 to 1982, there was no nightlife on Beale Street. But the music did not die. It was kept alive in the hearts and souls of Memphians and fans around the world. (Mississippi Valley Collection.)

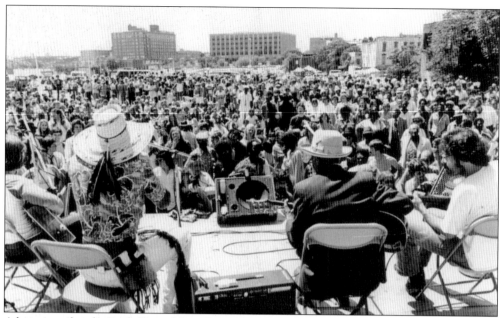

A huge crowd at the Beale Street Music Festival in 1979 cheers Furry Lewis and his band. In 1977, as the city was acquiring what was left of Beale Street and seeking a developer, the Memphis in May International Festival was established. The Beale Street Music Festival was the kick-off event. B. B. King played at midnight to 6,500 people, black and white, young and old. (Mississippi Valley Collection.)

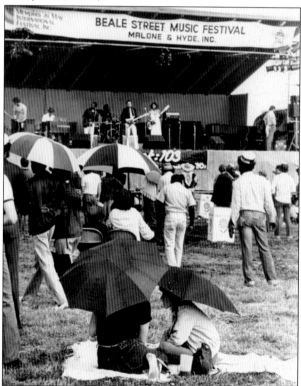

Shown here is the Beale Street Music Festival in 1983. The festival is now held in Tom Lee Park on the riverfront at the foot of Beale Street. Rain or shine, the crowds come to enjoy the music. Every year the festival has grown; it now attracts some 150,000 fans to hear over 60 major acts from numerous genres on four stages over three days. (Mississippi Valley Collection.)

This poster for the 2004 Beale Street Festival features the artwork of Memphian George Hunt. The festival hosted Little Milton, Funkadelic, Chaka Khan, Indigo Girls, Styx, Buddy Guy, Charlie Musselwhite, the Drive-By Truckers, and many more. (Janann Sherman.)

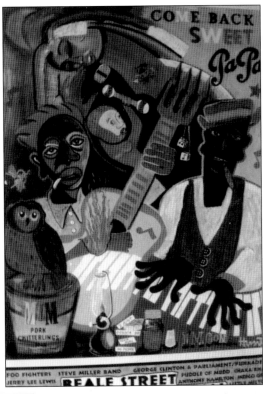

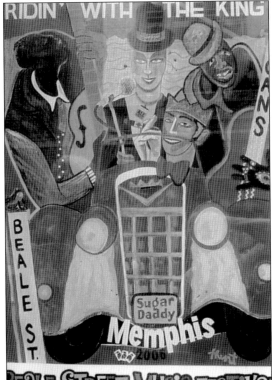

In 2006, a host of hall-of-famers appeared at the festival. "Riding with the King," Elvis Presley, are Bo Diddley, Little Richard, B. B. King, Jerry Lee Lewis, Little Richard, Booker T. and the MGs, and Billy Lee Riley. Also appearing were Three 6 Mafia, Shinedown, Disco Biscuits, Huey Lewis and the News, Yonder Mountain String Band, and Saffire—the Uppity Blues Woman. (Janann Sherman.)

Live music is a regular feature of the modern Beale Street as it was with the old. Professional and amateur, large groups and small jam and play in Handy Park, in the alleys, and along the sidewalks of Beale. (Mississippi Valley Collection.)

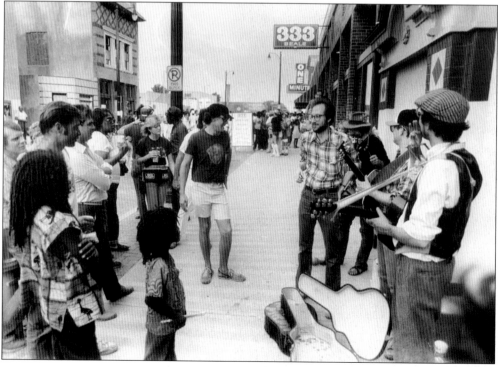

Beale Street music is more than just sounds, it's feelings, the breath of life. Herman Young gets his mojo working listening to Beale Street music. (Mississippi Valley Collection.)

"Memphis music is an approach to life," wrote Robert Gordon in *It Came from Memphis*. "Memphis has always been a place where cultures came together to have a wreck: black and white, rural and urban, poor and rich. . . . These sounds touched the soul of society; unlike passing fads, these sounds have remained with us." The beat goes on. Now appearing at the Rum Boogie Café. . . . (Beverly Bond.)

Ruby Wilson is the undisputed Queen of Beale Street. A dynamic, energetic, and soulful singer, Wilson's style is sassy and sultry, powerful and emotional. Although she has taken her unforgettable voice worldwide, when she's in Memphis, she often performs at the club owned by the man she calls her "godfather," B. B. King. She was named Best Entertainer 2005–2006 by the annual Blues Ball. (William Bearden.)

Six

1968

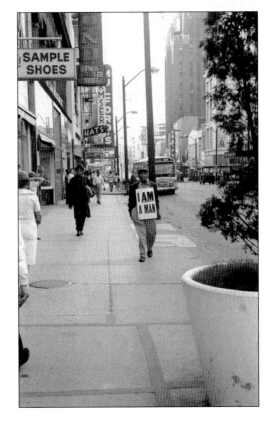

In January 1968, over 1,100 city sanitation workers went on strike. Workers were pressing for an increase in the wages that still left them eligible for welfare, a handful of basic benefits like health care, an end to differential treatment by race, recognition of their union, and, as this man's sign reflects, their own dignity as men. (Douglas Cupples.)

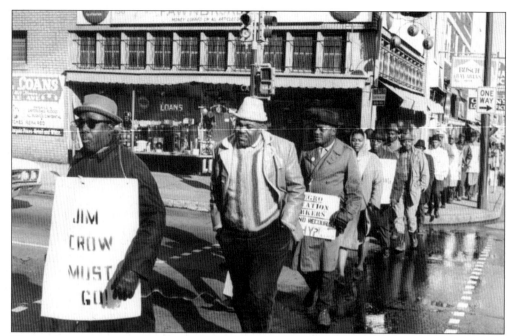

The precipitating incident for the strike was when rain canceled a workday and 22 sewer and drain workers received pay for only two hours, while their white supervisors collected full pay. It then accelerated when two black workers were accidentally crushed to death in a garbage compactor, and their widows received no insurance benefits. (Mississippi Valley Collection.)

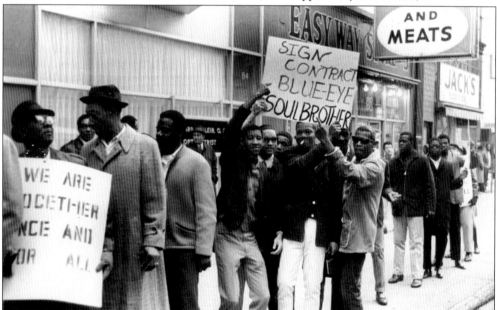

City sanitation workers were part of the working poor. For the hard physical labor of fixing streets and collecting garbage, many of them earned less than the federal poverty level of $3,000 per year. With an hourly pay scale of between $1.27 and $1.60 per hour, workers could barely reach the poverty level if the weather permitted them to work full time. Median family income for African Americans was $2,666, compared to $6,031 for white families. (Mississippi Valley Collection.)

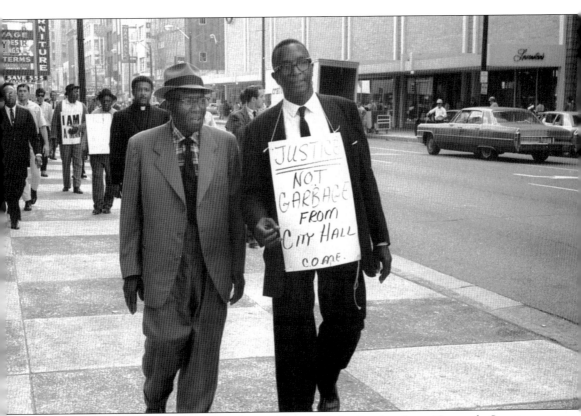

The group gathered at Clayborn Temple, an African Methodist church on Hernando Street a block south of Beale Street. Led by Rev. James Lawson, pastor of Centenary Methodist Church, and including a host of African American ministers and other community leaders, they proceeded in orderly single file to city hall. The men hoped to convince Mayor Henry Loeb to recognize and negotiate with their union, The American Federation of State, County, and Municipal Employees (AFSCME) local 1733. Mayor Loeb, however, insisted that public employees were not permitted to strike. Therefore, he said the strike was illegal, and he refused to yield. "Return to work or be fired," he told the men. (Douglas Cupples.)

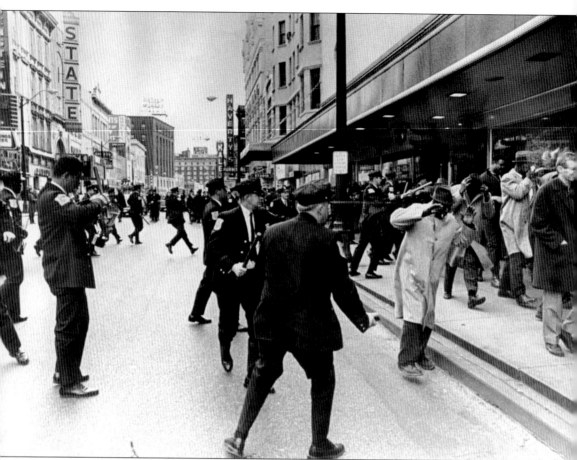

After a four-hour emergency city council meeting, during which union calls for compromise were soundly rejected, angry men led by ministers poured into the streets. As they marched along Main Street, police squad cars and hundreds of police on foot approached the marchers. The police cars edged toward the crowd, pressing them into a narrow line. Suddenly someone yelled they'd run over her foot. The men nearest her began rocking the squad car. Police inside leaped out, and other police rushed over. All along the march, police were moving in, spraying Mace at the marchers and beating them with nightsticks. The melee ended the march but raised the stakes for the city. Reverend Lawson told the assembly later that had they been white ministers, they would not have been maced. (Mississippi Valley Collection.)

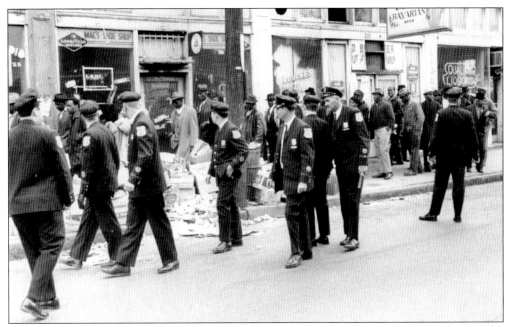

Police gather on Beale Street in anticipation of further marches. Note the piles of garbage in the street. Sanitation workers had been handling 2,500 tons of garbage daily. As the strike continued, it began to accumulate. A few garbage trucks manned by supervisors and trailed by police cars moved through the streets but made little headway against the increasing waste. (Mississippi Valley Collection.)

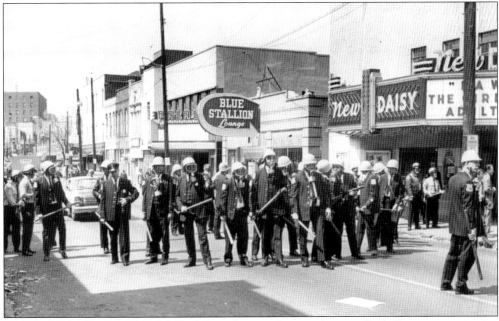

A phalanx of police, armed with billy clubs and gas masks, spreads across Beale Street in anticipation of confronting sanitation strike marchers. The escalating violence only served to harden positions on both sides. The mayor's office remained unwilling to meet with strike leaders; strikers began planning a downtown boycott and daily marches. (Mississippi Valley Collection.)

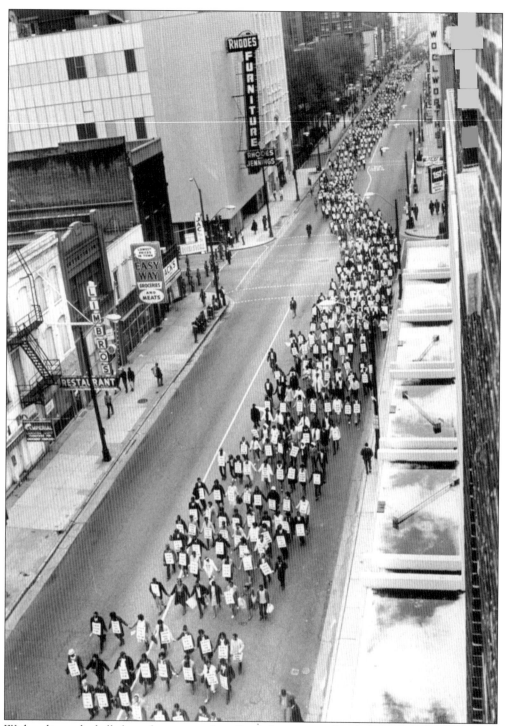

With police staked all along the route and a police helicopter overhead, the peaceful march snakes its way down Main Street. Nearly every marcher is wearing the iconic sign that characterized the Memphis civil rights movement for economic justice and social dignity: "I Am a Man." (Mississippi Valley Collection.)

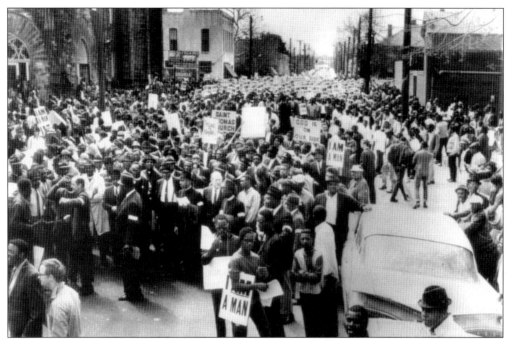

The escalating violence began to attract a broader base of support for the strikers, including white ministers and business leaders and several hundred white trade unionists. They gathered here in front of Clayborn Temple for yet another march to city hall. (Mississippi Valley Collection.)

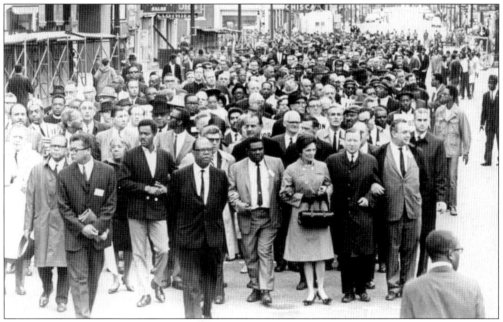

Rev. Lawson invited Dr. Martin Luther King Jr. to come to Memphis in support of the strike. King was organizing his Poor People's Campaign to confront the issues of poverty and hunger in America. He recognized that the plight of the sanitation workers in Memphis was part of the battle. He called the protest "a strike for the dignity of labor." King led a demonstration on March 28. (Mississippi Valley Collection.)

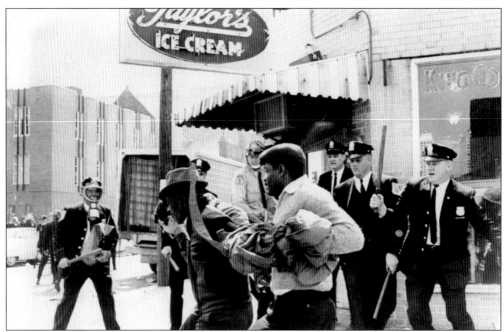

There was great tension in the city as King led thousands of marchers—black and white, ministers and strikers, businessmen and women, and mothers with children—down Hernando Street to Beale Street. Rumors, including one that said police had killed a girl at Hamilton High School that morning, circulated in the heated atmosphere. (Mississippi Valley Collection.)

At the back of the line were the young people, many adopting the angry rhetoric of the militants among them, taunting police and shouting for "black power." As the march moved along Beale Street, they threw bottles and bricks, smashing windows amid shouts of "smash glass" and "burn it down, baby." Up at the front of the line, King and the ministers suddenly became aware of the chaos at the back. The peaceful demonstration had become a riot. Police response left one dead, 64 injured, and more than 300 arrested. (Mississippi Valley Collection.)

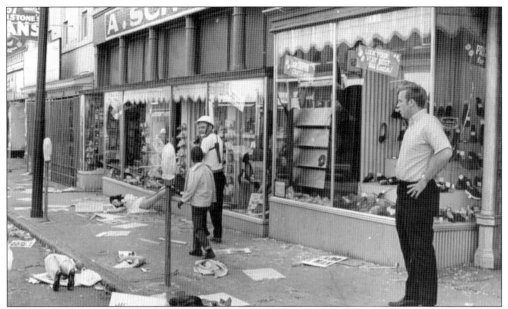

Dozens of businesses along Beale Street were looted, including Uncle Sam's Pawn Shop, Lansky Brothers clothing, Pape's Men's Store, Quality Liquors, and the venerable A. Schwab's department store. Broken windows and littered sidewalks remained as silent testimony to the failure of nonviolence. King was hustled out of harm's way, but the damage to his reputation as a nonviolent leader was in shambles. With little choice, King vowed to return to lead a non-violent march in April. (Mississippi Valley Collection.)

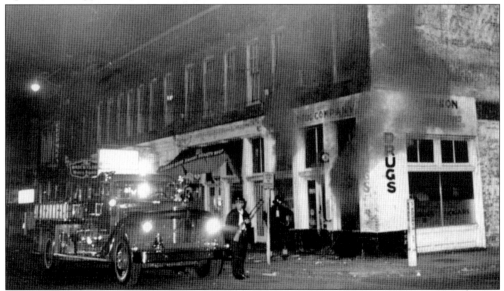

Fires burned, and there were scattered reports of sniping, firebombing, and looting throughout the night. Until now, Memphis had been spared the four long hot summers of urban riots that had plagued major cities across the nation. Estimates of the damage from the riot included 200 buildings with broken windows, most of them along Beale Street; goods were looted in about 35 percent of these stores. The loss to merchants was estimated to exceed $400,000. (Mississippi Valley Collection.)

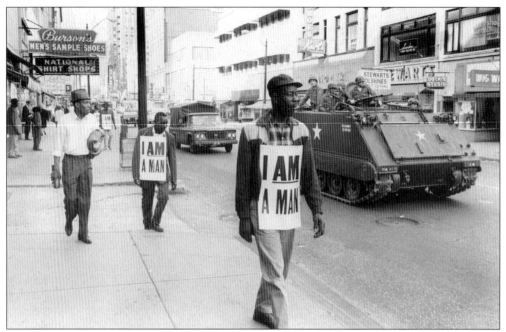

National guardsmen poured into the city from all over West Tennessee. With them came eight armored personnel carriers and other heavy equipment. It was reported one convoy moving into the city was strung out along five miles. The guard was used to augment the police, patrol the streets, and keep the peace. (Mississippi Valley Collection.)

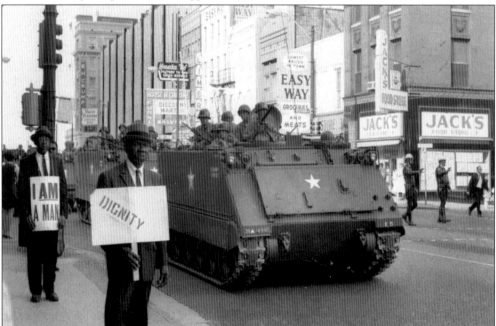

The strikers continued to march, but this time they shared the streets with the heavy military presence. The pleas for personal dignity, economic equality, and racial justice continued despite the threatening appearance of the National Guard. Mayor Loeb remained adamant that he would not negotiate with workers involved in an illegal strike. (Tommy Towery.)

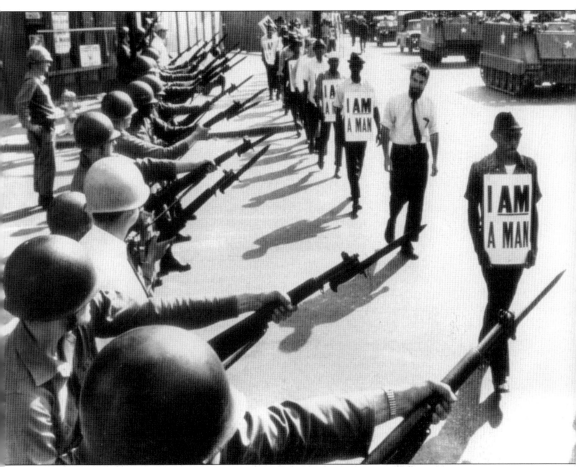

The local press, and national ones as well, blamed the whole fiasco on Dr. Martin Luther King Jr. He was, they said, an outside agitator, irresponsibly using Memphis as a testing ground for his Poor People's Campaign. In the U.S. Congress, speakers demanded that, with the evidence of Memphis before them, the Poor People's March on Washington, planned for the summer, be called off. (Mississippi Valley Collection.)

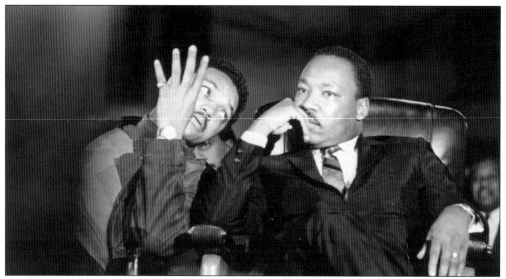

Martin Luther King Jr. (right) returned to Memphis determined to prove that nonviolence was still a viable strategy. The march was set for April 4. He and members of the Southern Christian Leadership Conference arrived on April 3 and took up residence in the Lorraine Motel. In this photograph, taken on April 3 at Mason Temple, King and Rev. Jesse Jackson confer as King prepares to speak at Mason Temple to some 3,000 people who had braved a violent thunderstorm to attend. (Mississippi Valley Collection.)

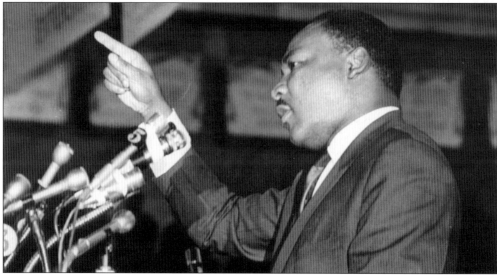

Dr. King began talking informally about his trip from Atlanta and discussions about his safety, "about what would happen to me from some of our sick white brothers. Well, I don't know what will happen now. We've got some difficult days ahead. But it really doesn't matter with me now. . . . Like anybody else, I would like to live a long life. Longevity has its place. But I'm not concerned about that now. I just want to do God's will. And he's allowed me to go up to the mountain, and I've looked over, and I've seen the Promised Land. I may not get there with you. But I want you to know tonight that we as a people will get to the Promised Land. So, I'm happy tonight. I'm not worried about anything. I'm not fearing any man. Mine eyes have seen the glory of the coming of the Lord!" (Mississippi Valley Collection.)

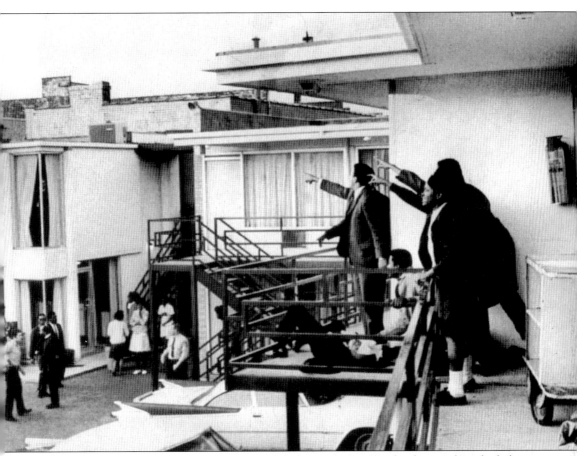

On April 4, as King was preparing for his march, he was assassinated as he stood on the balcony outside Room 306 of the Lorraine Motel. A single rifle shot fired from the bathroom of a boarding house across the street shattered King's jaw, and he died within minutes. Pointing to the source of the shot as they stand beside the fallen King are Andrew Young, Rev. Billy Kyles, Rev. Jessie Jackson, and Rev. Ralph Abernathy. (Mississippi Valley Collection.)

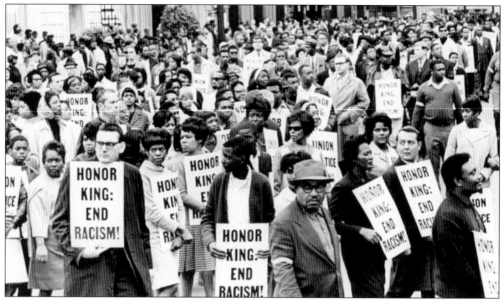

Four days after the death of her husband, Coretta Scott King and her children led a completely silent march of some 40,000 people through the streets of Memphis. On April 16, two weeks after King was shot, after 65 bitter days, the city settled with the sanitation workers, recognized their union, and agreed to a modest raise. But great damage had been done to the city's race relations and its national reputation. Everyone knew that Memphis was the place where Dr. King was killed. (Mississippi Valley Collection.)

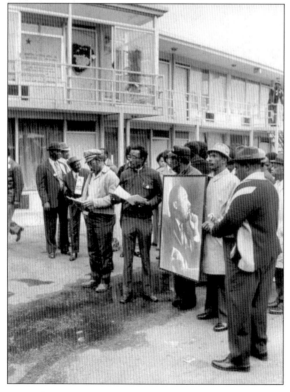

A group of concerned citizens formed the Martin Luther King Memorial Foundation to save the Lorraine Motel as a shrine to the fallen leader. Note the wreath on the door and the protective glass around the balcony where he fell. The Lorraine was reborn as the National Civil Rights Museum in 1991 with 16 galleries to tell the story of the African American freedom struggle from the 1600s to the present. A plaque outside Room 306 quotes Genesis: "They said to one another, behold here cometh the Dreamer. Let us slay him and we shall see what becomes of his dreams." (Mississippi Valley Collection.)

Seven

DEMOLITION AND (RE)DEVELOPMENT

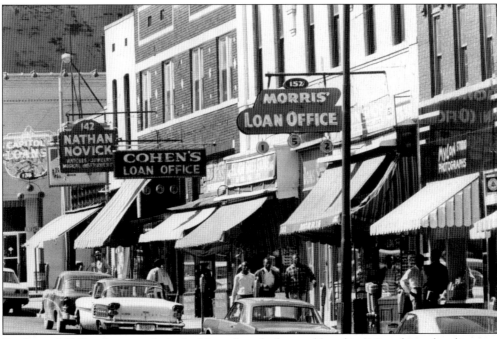

By the mid-1960s, the central city had been largely deserted by white Memphians heading east to the suburbs, taking retail establishments, businesses, and jobs with them. Beale Street, a street that had slowly faded from its heyday in the 1920s to 1950s was now tawdry and cheap, home to many pawnshops, loan establishments, and stores selling cut-rate liquor and discount clothing. (Mississippi Valley Collection.)

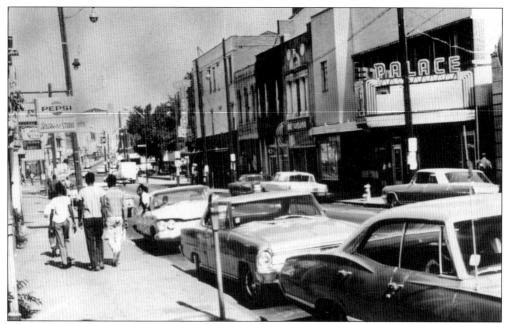

The old theaters were still there but the marquees were empty, and many of the stores were boarded up. Urban renewal fervor had hit Memphis in the 1950s, initiated by a federal program designed to replace slum housing with new housing. But it had not yet turned its attention to Beale Street. (Mississippi Valley Collection.)

In the mid-1960s, the Memphis Housing Authority's market analysts indicated that a revived Beale Street commercial district could help stabilize retail sales in a downtown increasingly in competition with suburban shopping centers. In anticipation of development, the three-block core of Beale Street businesses was listed on the National Register of Historic Places. (Mississippi Valley Collection.)

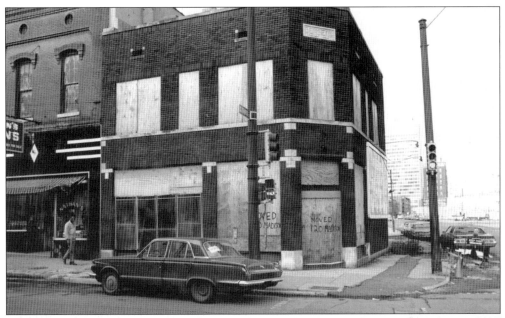

The Beale Street I project, covering approximately 150 acres along Beale Street from the river bluff to Danny Thomas Boulevard, was proposed in 1966 to convert Beale Street into a city centerpiece with high-rise apartments, a hotel and convention center, a new auditorium for Church's Park, and a multi-level pedestrian mall. Tied up in federal red tape until 1969, the project was abandoned in the wake of the King assassination in April 1968. (Memphis Room.)

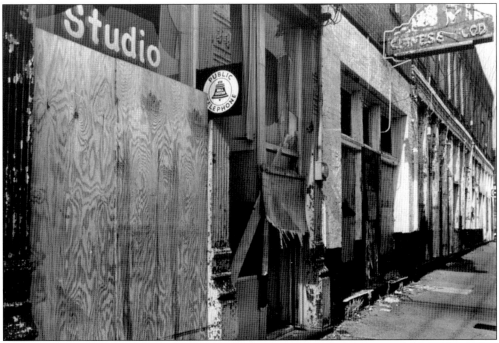

The riots that accompanied the sanitation workers' strike and the King marches in Memphis left Beale Street a shamble of plywood-covered windows and burned-out stores. (Mississippi Valley Collection.)

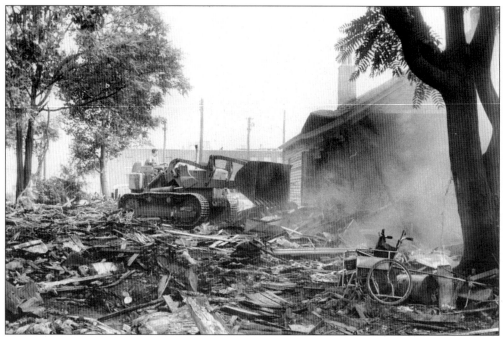

From 1970 to 1973, the bulldozers rolled through the neighborhood. In the Beale Street I area, the Memphis Housing Authority (MHA) demolished 300 substandard buildings, including the Loew's State Theater on South Main where Elvis Presley once worked as an usher and the Randolph office building at the corner of Main and Beale. The Orpheum Theater across the street was spared. (Mississippi Valley Collection.)

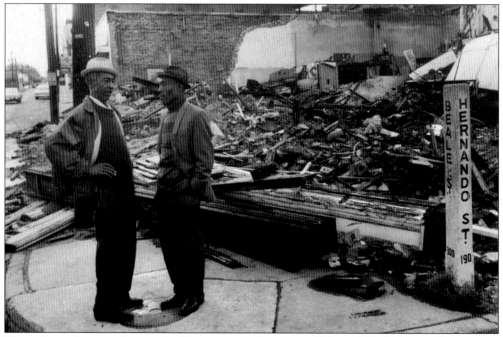

Throughout the area, historic buildings were reduced to rubble and hauled away. (Mississippi Valley Collection.)

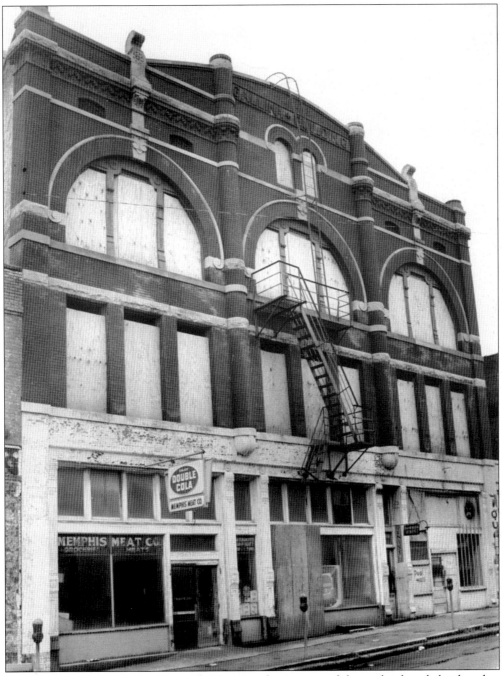

Built in 1891, the Gallina Exchange Building was three stories of elegant brickwork, brick arches framing the third-story windows with a terra cotta cornice at the top. Among the grandest structures on Beale Street, heroic efforts were made to save her. (Memphis Room.)

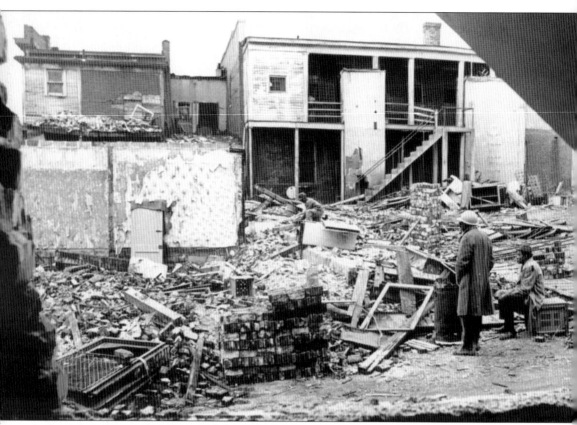

A commentator at the time noted that urban renewal meant Negro removal. There was little left to be salvaged among what was left of leveled apartment buildings, business offices, and stores. (Mississippi Valley Collection.)

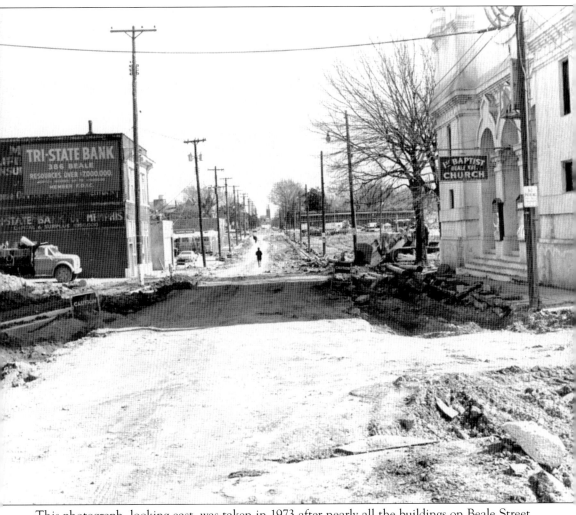

This photograph, looking east, was taken in 1973 after nearly all the buildings on Beale Street were demolished for urban renewal. The street resembled a bombed-out war zone. On this end of Beale Street, all that remained of the "Main Street of Negro America" was Historical First Baptist Beale on the right and the old Solvent Savings Bank building across the street on the left. (Mississippi Valley Collection.)

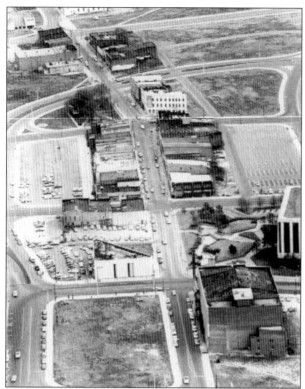

When it was all over, two urban renewal projects, dubbed Beale Street I and II, had leveled every building north and south of Beale Street and along one block of Beale Street itself, demolishing 474 buildings, displacing more than 300 families, reducing the resident population to zero, and leaving behind a score of empty lots and a thin commercial district between Second and Fourth Streets. The Orpheum Theater is on the lower right. (Mississippi Valley Collection.)

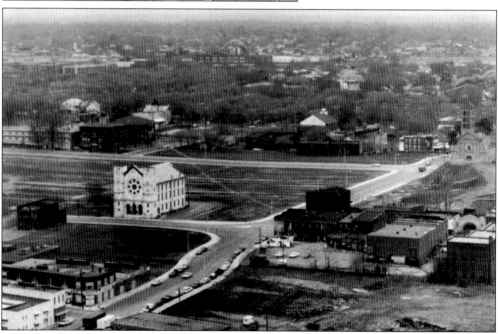

The Historical First Baptist Beale stands alone facing Beale Street just east of Fourth Street. What was once Church's Park is to the left of the church. The *Press Scimitar* remarked in June 1976, "Urban renewal destroyed Beale Street, and with it, a part of Memphis." (Mississippi Valley Collection.)

What was left of Beale Street was offered for bids from developers. Beale Street U.S.A., approved by the MHA in 1973, failed to obtain financial backing. In 1974, the Beale Street National Historic Foundation assumed responsibility but failed to advance the project. (Mississippi Valley Collection.)

By 1977, the city had purchased the remaining properties along three blocks of Beale. In 1982, the city granted John Elkington, owner of Performa Entertainment, a 52-year lease on the properties as inducement to develop Beale Street into an entertainment district. One of its first projects was to restore the historic cobblestones that lined Beale Street. (Mississippi Valley Collection.)

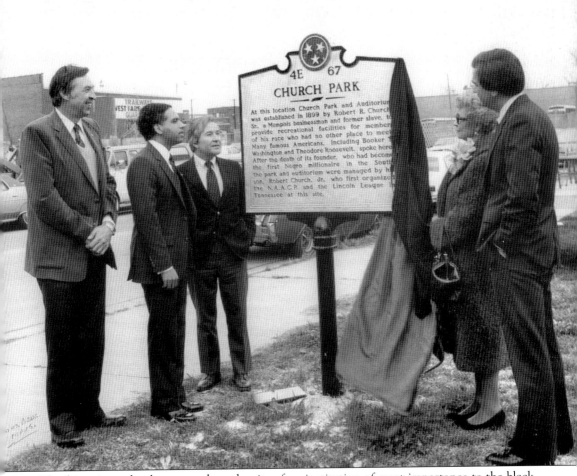

This historic marker honors, at last, the site of an institution of great importance to the black community on Beale Street. Attending this dedication ceremony on March 23, 1983, are, from left to right, Earnest Williams III, Ronald Walter, historian Charles Crawford, Roberta Church (granddaughter of Robert R. Church Sr.), and Memphis mayor Richard Hackett. (Mississippi Valley Collection.)

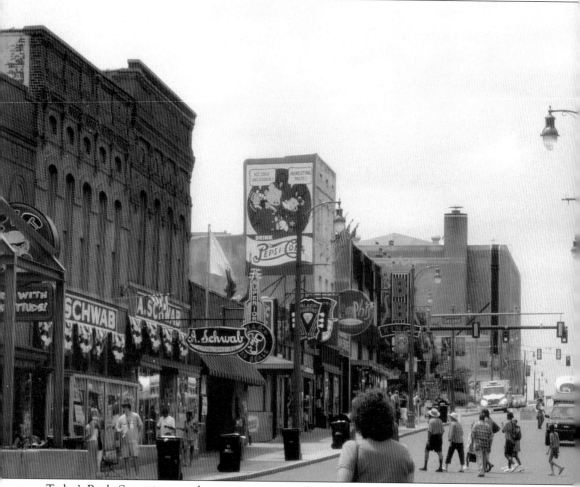

Today's Beale Street is a popular tourist attraction lined with stores, restaurants, and clubs. This photograph looking west from Third Street shows, from left to right, the steel girders holding up the facade of the Gallina Building, the Pig barbecue restaurant, A. Schwab's department store, and the Black Diamond Club. B. B. King's is on the corner of Second and Beale Streets. The Orpheum Theater is the large building at center right. (Janann Sherman.)

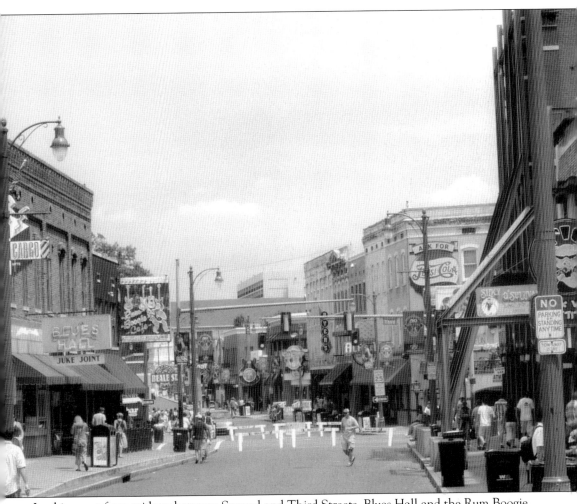

Looking east from midway between Second and Third Streets, Blues Hall and the Rum Boogie Café are on the left. On the right is the Pig and Silky O'Sullivan's bar and restaurant behind the Gallina Building facade. Proceeding down the right side, past Third Street, is Alfred's, Wet Willie's, and the Hard Rock Café. Across from Alfred's on the north side of Beale Street is Handy Park and Pavilion. Further east lie the Daisy and New Daisy Theaters, the Celebrity Club, and the First Baptist Beale Street Church. (Janann Sherman.)

Shops along Beale Street do a thriving business in tourist goods and musical memorabilia. Their inventories include teddy bears, dolls, salt and pepper shakers, posters, dishware, t-shirts and hats, and funky art novelties galore. (Beverly Bond.)

Inside A. Schwab's is a unique collection of geegaws and gimcracks. Where else could one buy magnets reflecting the new icons of Beale Street—blues, booze, and barbecue—along with Fresh Cans of Rock and Roll and Giant Buckets of Blues? (Beverly Bond.)

Even on a hot summer afternoon, people come to Beale Street to experience its mystique. At night, the streets are crowded with tourists and locals, people dressed up and dressed down. The Black Diamond Club serves up barbecue and some of the best local and national blues bands nightly. Next door, Tater Red's is known for its "Lucky Mojos" and "Voodoo Healings." This is the only place around to buy such items as Voodoo dolls, black cat bones, tarot cards, and goofer dust. (Beverly Bond.)

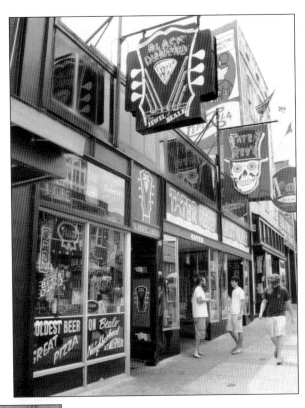

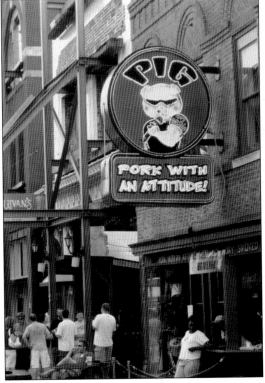

The Pig on Beale Street specializes in slow-cooked, hickory-smoked barbecue, the taste and smell that made Memphis ribs world famous. Memphis barbecue has a history that probably reaches all the way back to 16th-century explorer Hernando DeSoto. The Spanish conquistador carried his food supply on the hoof. When he reached the banks of the Mississippi near present-day Memphis, some of his pigs were no doubt slow-roasted over an open fire, beginning the tradition of Memphis barbecue. (Beverly Bond.)

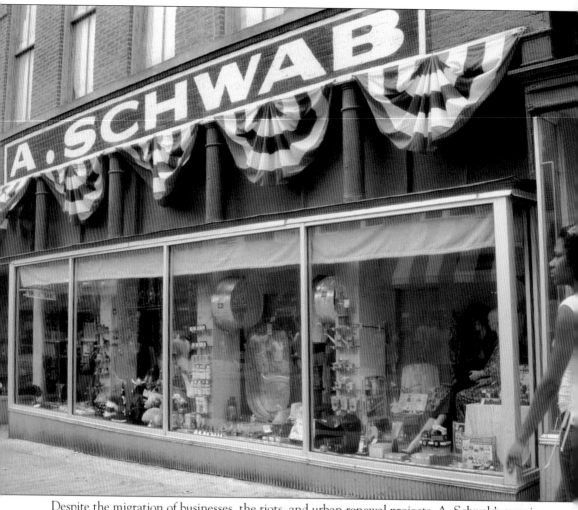

Despite the migration of businesses, the riots, and urban renewal projects, A. Schwab's remains a fixture on Beale Street. This family-owned dry goods store has been here since 1876, and is the only original business still operating on Beale. The second-floor museum provides a glimpse of merchandising in the 19th and early 20th centuries. (Janann Sherman.)

A. Schwab's, with its high ceilings and old-fashioned display bins, has changed little over the years. Abe Schwab always bragged that his merchandise was 50 years behind the times. The store continues to carry merchandise long disappeared from other, more modern stores, like Fels Naptha and zinc washtubs. (Janann Sherman.)

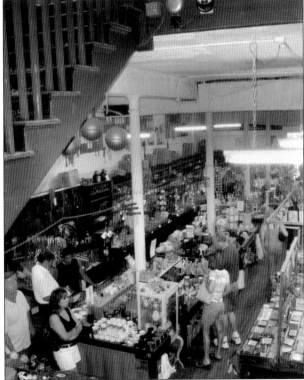

A. Schwab's rectangular display islands are piled high with curios, clothing, household goods, hardware, mechanical toys, and other assorted stuff. The store's slogan is "If you can't find it at Schwab's, you probably don't need it." (Janann Sherman.)

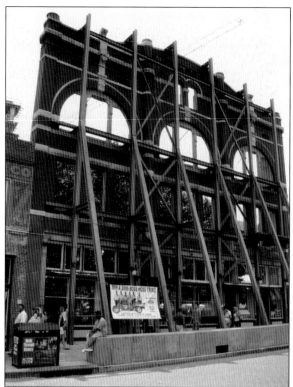

Other Beale Street structures have not been as lucky as A. Schwab's. All that remains of the elegant Gallina Exchange Building is the facade shored up with six steel girders; the building was so badly damaged it could not be salvaged. City building codes prevent its renovation because it is sitting atop the Gayoso Bayou. The area behind the facade is an open-air bar and entertainment area, part of Silky O'Sullivan's operation next door. (Beverly Bond.)

Mr. Handy's Blues Hall symbolizes the street's proud heritage of blues music and juke joints. Along the two-block stretch between Second and Fourth Streets, a newly reborn Beale Street still throbs with music of all kinds but mainly the blues. (Beverly Bond.)

The Rum Boogie Café, established in 1985, was one of the first clubs to open on the refurbished Beale Street. Housing a collection of 350 guitars, the club features live music and Cajun food. (Beverly Bond.)

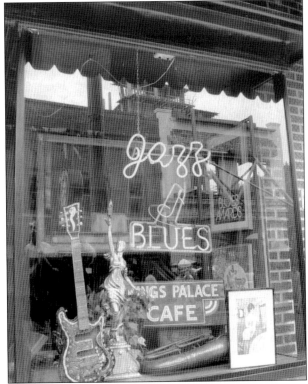

King's Palace has been serving its famous gumbo since the redevelopment of the street, pairing good food with great live music. (Janann Sherman.)

A fresh coat of paint on the Daisy Theater highlights the art deco exterior. During Beale Street's heyday, the Daisy was a performing venue for the many traveling acts that stopped in Memphis. During the 1980s, it was renovated and reopened as the Beale Street Blues Museum. (Beverly Bond.)

The FedEx Forum is a $250-million basketball arena. It was completed in the fall of 2004 and is located at 191 Beale Street at Third Street. The facility is home to both the NBA's Memphis Grizzlies and the University of Memphis Tigers basketball team. (Beverly Bond.)

Now the Celebrity Club, this building once housed the Monarch Club, a gambling establishment with trap doors and secret exits. The Monarch Club was known as the "castle of missing men" because those who lost gambling disputes were easily disposed of at the undertaking establishment across the alley. (Janann Sherman.)

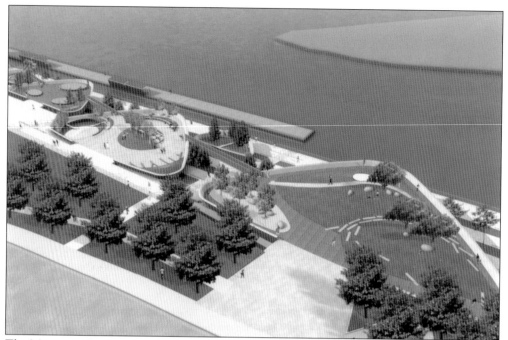

The Mississippi River remains a focal point of plans for Beale Street. The Beale Street Landing Project will be built where Beale Street meets Tom Lee Park, along the cobblestone landing where Mississippi riverboats once stopped for their visitors to go ashore and for roustabouts to load cotton bales for the trip to distant markets. (Riverfront Development Corporation.)

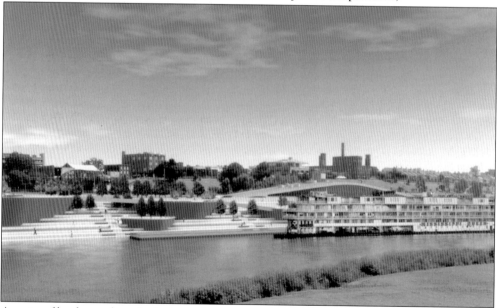

A series of landscaped overlooks formed on a ramped slope and connected by pedestrian bridges is designed to provide space for riverfront activities while accommodating the fluctuation of the Mississippi River. Work on the project began in the spring of 2005 and is slated to be completed in early 2008. The wharf, the street, and the music—all will carry Beale Street into the 21st century much as they have for the past two centuries. (Riverfront Development Corporation.)

BIBLIOGRAPHY

Bearden, William. *Memphis Blues: Birthplace of a Music Tradition*. Charleston, SC: Arcadia Publishing Company, 2006.

Beifuss, Joan Turner. *At the River I Stand*. Memphis: St. Luke's Press, 1990.

Biles, Roger. *Memphis in the Great Depression*. Knoxville: University of Tennessee Press, 1986.

Bond, Beverly G. and Janann Sherman. *Memphis in Black and White*. Charleston, SC: Arcadia Publishing Company, 2003.

Cantor, Louis. *Wheelin' on Beale*. New York: Pharos Books, 1992.

Capers, Gerald. *The Biography of a River Town*. New York: Vanguard, 1966.

Church, Roberta and Ronald Walter; Charles W. Crawford, ed. *Nineteenth Century Memphis Families of Color 1850–1900*. Memphis: Murdock Printing Company, 1987.

Coppock, Helen M. and Charles W. Crawford, eds. *Paul R. Coppock's Mid-South, Vol. I–Vol. IV*. Memphis: Paul R. Coppock Publication Trust, 1985–1994.

Gordon, Robert. *It Came from Memphis*. Boston: Faber and Faber, 1995.

Hamilton, G. P. *The Bright Side of Memphis*. Memphis: G. P. Hamilton, 1908.

Kirby, Edward. *Memories of Beale Street Memphis: Where It All Began*. Memphis: Penny Pincher Sales, 1979.

Lamon, Lester. *Blacks in Tennessee 1791–1970*. Knoxville: The University of Tennessee Press, 1981.

Lauderdale, Vance. *Ask Vance*. Memphis: Bluff City Books, 2003.

Lee, George W. *Beale Street: Where the Blues Began*. New York: Robert O. Ballow, 1934.

Lewis, Selma S. and Marjean G. Kremer. *The Angel of Beale Street: A Biography of Julia Ann Hooks*. Memphis: St. Luke's Press, 1986.

Magness, Perre. *Good Abode: Nineteenth Century Architecture in Memphis and Shelby County, Tennessee*. Memphis: The Junior League of Memphis, Inc., 1983.

McKee, Margaret and Fred Chisenhall. *Beale Black and Blue: Life and Music on Black America's Main Street*. Baton Rouge: Louisiana State University Press, 1981.

Miller, William D. *Memphis During the Progressive Era*. Memphis: Memphis State University Press, 1957.

Raichelson, Richard. *Beale Street Talks*. Memphis: Arcadia Records, 1994.

Sigafoos, Robert A. *Cotton Row to Beale Street: A Business History of Memphis*. Memphis: Memphis State University Press, 1979.

Tucker, David M. *Lieutenant Lee of Beale Street*. Nashville: Vanderbilt University Press, 1971.

Walk, Joe. *A History of African-Americans in Memphis Government*. Self-published, 1996.

Wrenn, Lynette Boney. *Crisis and Commission Government in Memphis*. Knoxville: University of Tennessee Press, 1998.

Across America, People are Discovering Something Wonderful. Their Heritage.

Arcadia Publishing is the leading local history publisher in the United States. With more than 3,000 titles in print and hundreds of new titles released every year, Arcadia has extensive specialized experience chronicling the history of communities and celebrating America's hidden stories, bringing to life the people, places, and events from the past. To discover the history of other communities across the nation, please visit:

www.arcadiapublishing.com

Customized search tools allow you to find regional history books about the town where you grew up, the cities where your friends and family live, the town where your parents met, or even that retirement spot you've been dreaming about.